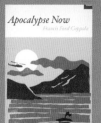 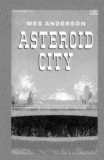 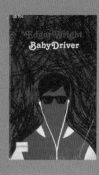 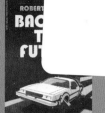 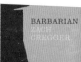 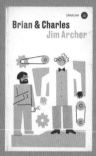 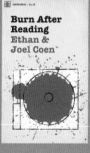 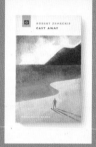 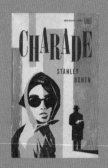 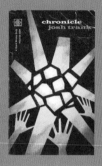 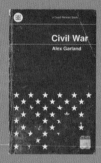 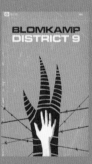 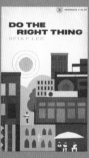 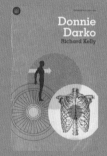 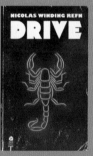 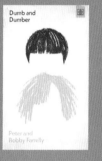 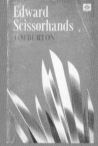 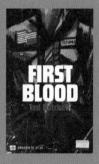 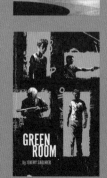 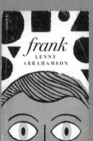 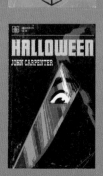 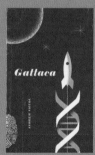 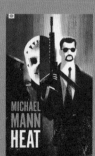 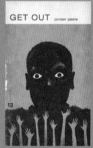 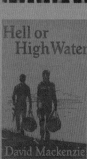 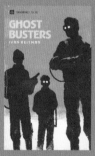 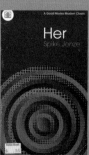

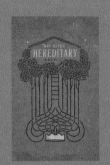
HEREDITARY

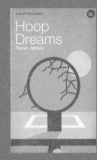
Hoop Dreams
Steve James

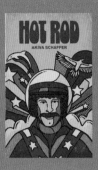
HOT ROD
AKIVA SCHAFFER

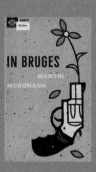
IN BRUGES
MARTIN McDONAGH

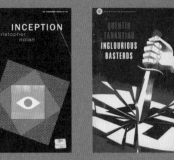
INCEPTION
christopher nolan

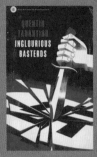
QUENTIN TARANTINO
INGLOURIOUS BASTERDS

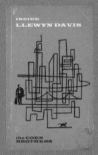
INSIDE LLEWYN DAVIS
the COEN BROTHERS

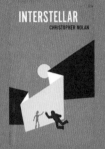
INTERSTELLAR
CHRISTOPHER NOLAN

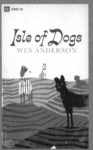
Isle of Dogs
WES ANDERSON

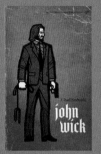
john wick

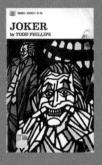
JOKER
by TODD PHILLIPS

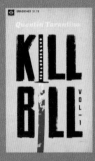
Quentin Tarantino
KILL BILL
VOL·I

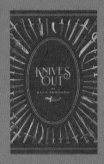
KNIVES OUT

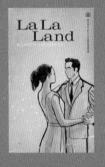
La La Land

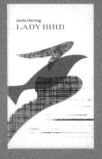
Greta Gerwig
LADY BIRD

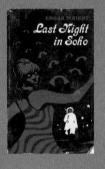
EDGAR WRIGHT
Last Night in Soho

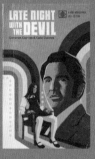
LATE NIGHT WITH THE DEVIL

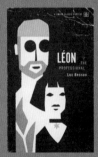
LÉON
THE PROFESSIONAL
Luc Besson

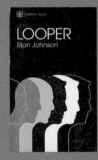
LOOPER
Rian Johnson

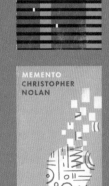
LOST IN TRANSLATION
by Sofia Coppola

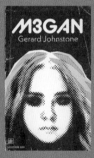
M3GAN
Gerard Johnstone

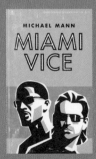
MAC AND ME
by STEWART RAFFILL
DIRECTOR OF THE SEA GYPSIES

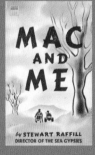
George Miller's
Mad Max: Fury Road

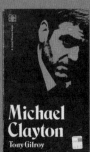
MANDY
PANOS COSMATOS

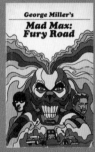
DEAN FLEISCHER CAMP
MARCEL THE SHELL WITH SHOES ON

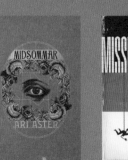
MEMENTO
CHRISTOPHER NOLAN

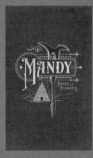
MICHAEL MANN
MIAMI VICE

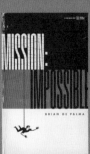
Michael Clayton
Tony Gilroy

MIDSOMMAR
ARI ASTER

MISSION: IMPOSSIBLE
BRIAN DE PALMA

Good Movies as Old Books

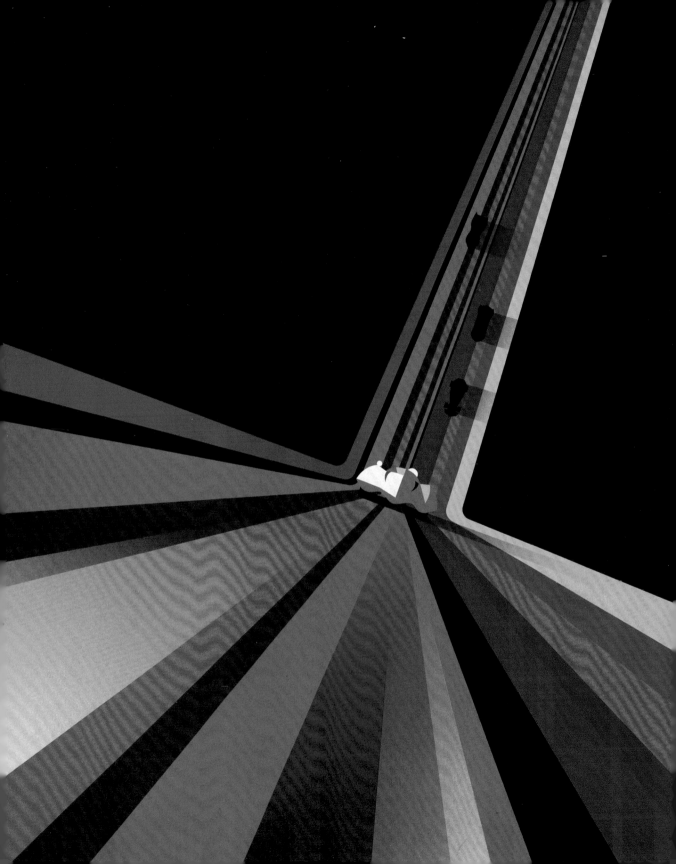

Good Movies as Old Books

Films Reimagined as Vintage Book Covers

BY MATT STEVENS

CHRONICLE BOOKS
SAN FRANCISCO

Contents

Foreword

A few years ago, I came across Matt Stevens's work and instantly fell in love. His passion for cinema and vintage book covers was evident in every piece. But what struck me most about Matt's work was how he seamlessly blends his love for movies with some of my favorite design styles of the past. You can really feel his personal connection to all of the films he depicts. It's like he's crafted a visual love letter to each movie, capturing the essence of their stories in a beautifully nostalgic way.

I love that Matt's choices are not a "best of" list. Instead, they're a bunch of rad movies that have had a lasting impact on his life. From *Mac and Me* to *Midsommar*, these films span a wide range of genres and eras, showcasing his deep appreciation for the power of cinema to evoke emotions and inspire creativity.

His art makes you feel like you are discovering these films for the first time—with that same excitement you felt as a kid after seeing a new movie poster. Matt's work has sent me on a journey to revisit each film. It's a testament to his skill as an artist and his genuine love for cinema. *Good Movies as Old Books* is a powerful, heartfelt homage to beloved films everywhere and the enduring impact they have on our lives.

— **Jared Hess**, co-writer and director
of *Napoleon Dynamite*, *Nacho Libre*,
and *Gentlemen Broncos*

Introduction

I was a kid who drew on everything. The corner of the Sunday newspaper, an old notecard left on the dining room table, or the flap of a random cardboard box. I'd set up to play paper football on our dining room table, but I'd spend the whole afternoon making a poster for the game instead of actually playing. I love the peaceful space of drawing and creating. Even though I illustrate and design for a living and love what I do, I'm always looking for spaces to make things that are my own. I never outgrew getting lost in imagining what *could be*.

Good Movies as Old Books came from an unexpected place. I had the opportunity to work on a commissioned project for my friend and collaborator Ryan Kalil— the idea was to reinvent a potential new movie property as an old book cover in service of a pitch. The work lit a spark in me. That spark became the inspiration for a three-plus-year project with over 250 individual pieces of art.

It's probably obvious by now that I also love movies. The first movie I ever *really* loved was *The Karate Kid*. I remember liking other movies—I had my world turned upside down by the end of *The Empire Strikes Back*, I was freaked out after seeing part of *Halloween* at a much too young age—but *The Karate Kid* was the first movie that really spoke to me. I had just moved to a new school in a new city, far away from where I grew up. I had lost my father a few years earlier and was trying to find my way as an awkward middle schooler in a new place. Seeing a character on the screen in a situation I could relate to that persevered and triumphed—it was formative. It set the path for what a movie could be for me, how I watched them, and what I responded to.

How you interact with this book is up to you, but for me, it's important to note it's not a "Best of" list. These are films that made me laugh, cry, think, question, and celebrate. To put it simply, I was moved to use what I love to do to express my affection for these films. I hope you see some movies you love in these pages or are inspired to check some of them out for the first time and find that same unexpected joy.

— **Matt Stevens**

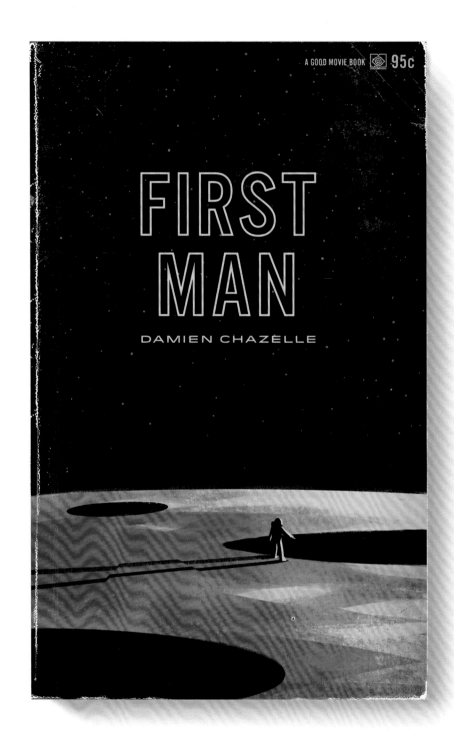

First Man (2018) / Director: Damien Chazelle / Writer: Josh Singer / Original Novel: James R. Hansen

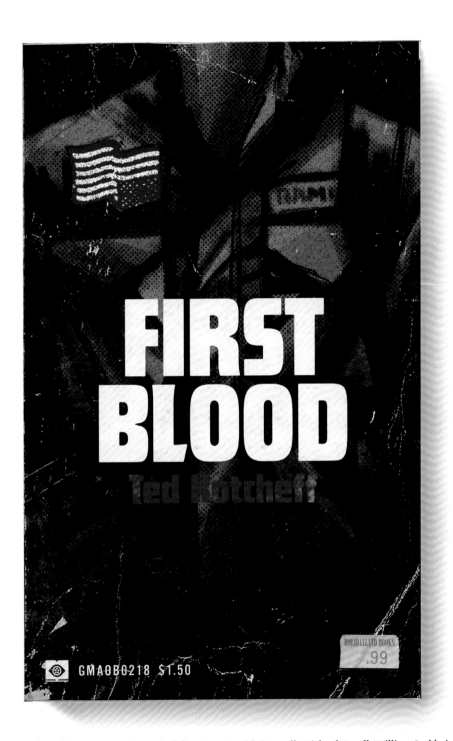

First Blood (1982) / Director: Ted Kotcheff / Writers: Davide Morrell, Michael Kozoll, William Sackheim

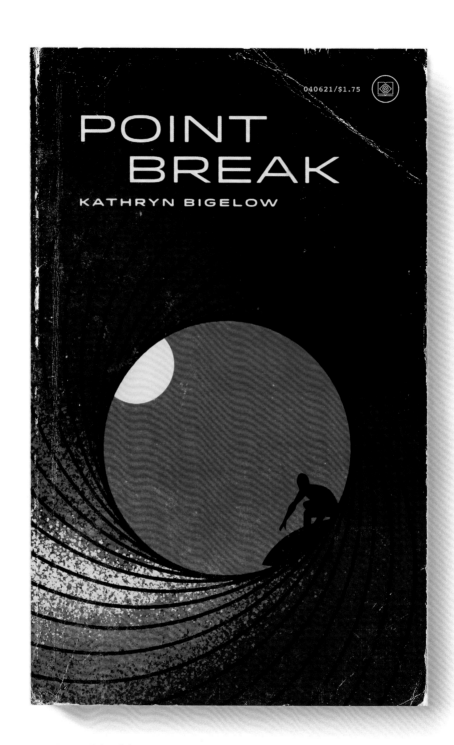

Point Break (1991) / Director: Kathryn Bigelow / Writers: Rick King, W. Peter Iliff

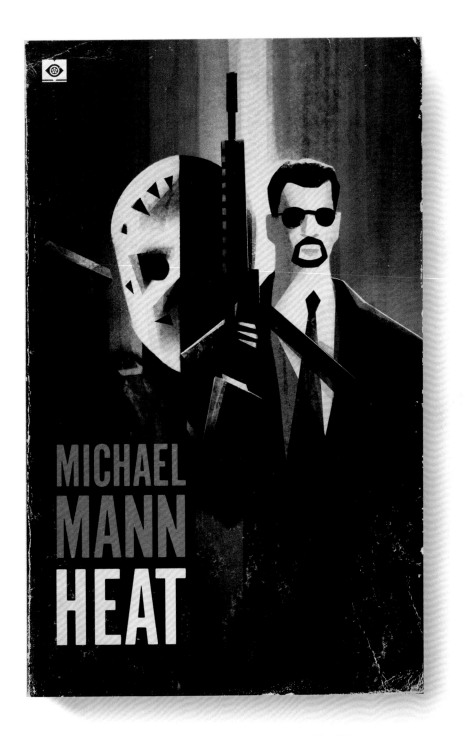

Heat (1995) / Director: Michael Mann / Writer: Michael Mann

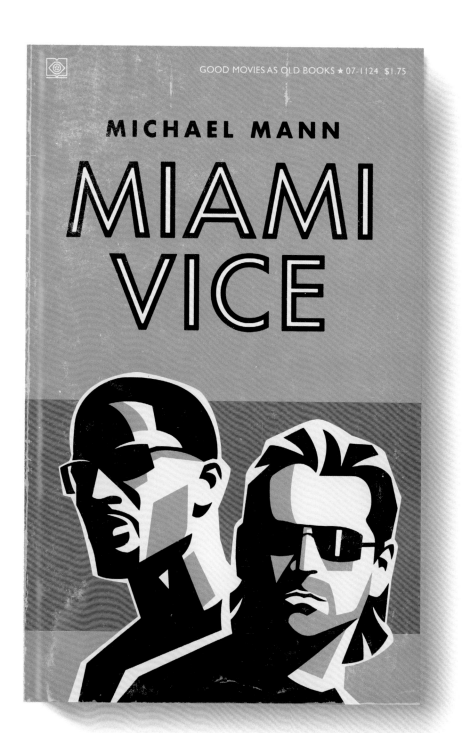

MICHAEL MANN

MIAMI VICE

Miami Vice (2006) / Director: Michael Mann / Writers: Michael Mann, Anthony Yerkovich

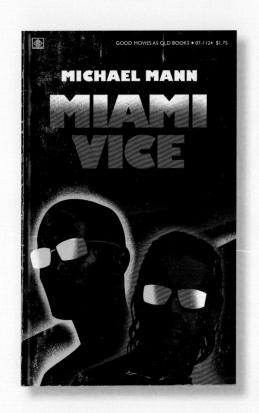

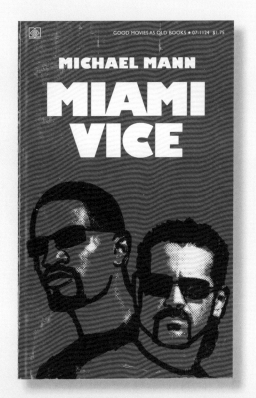

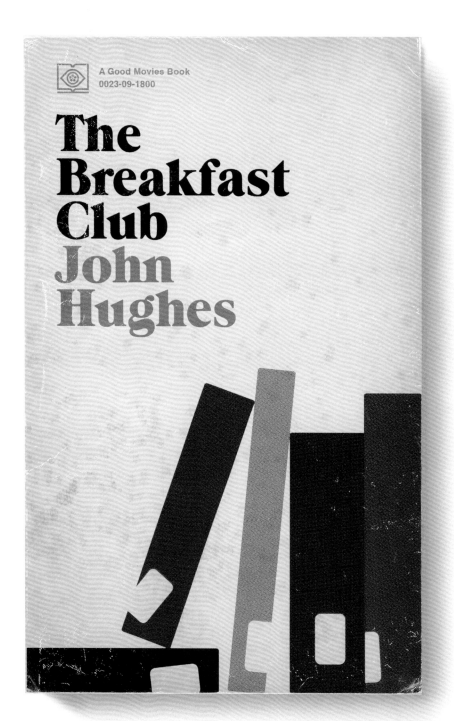

A Good Movies Book
0023-09-1800

The Breakfast Club
John Hughes

The Breakfast Club (1985) / Director: John Hughes / Writer: John Hughes

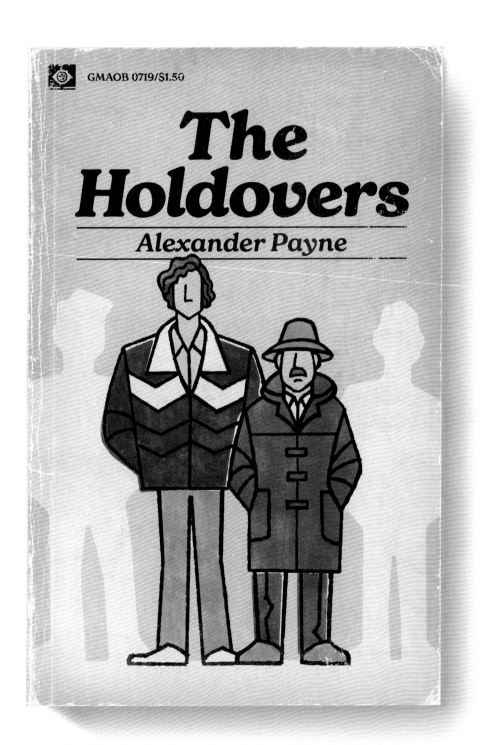

The Holdovers (2023) / Director: Alexander Payne / Writer: David Hemingson

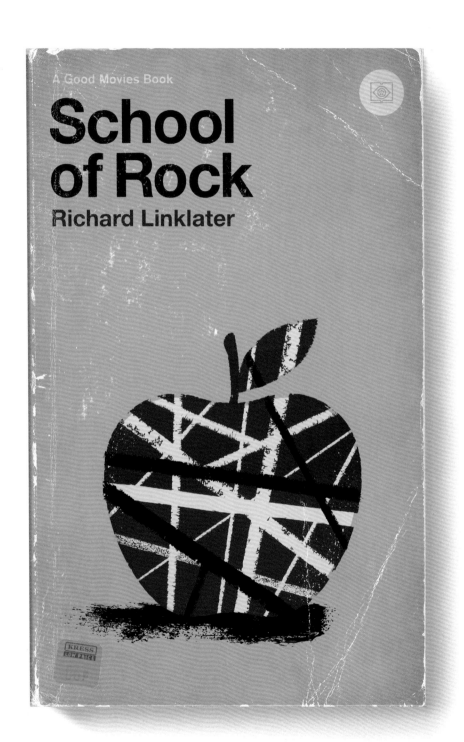

School of Rock (2003) / Director: Richard Linklater / Writer: Mike White

Some Kind of Wonderful (1987) / Director: Howard Deutch / Writer: John Hughes

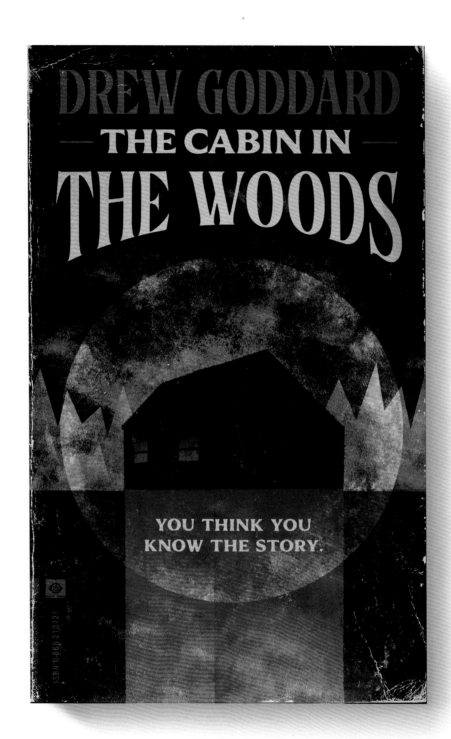

The Cabin in the Woods (2011) / Director: Drew Goddard / Writers: Joss Whedon, Drew Goddard

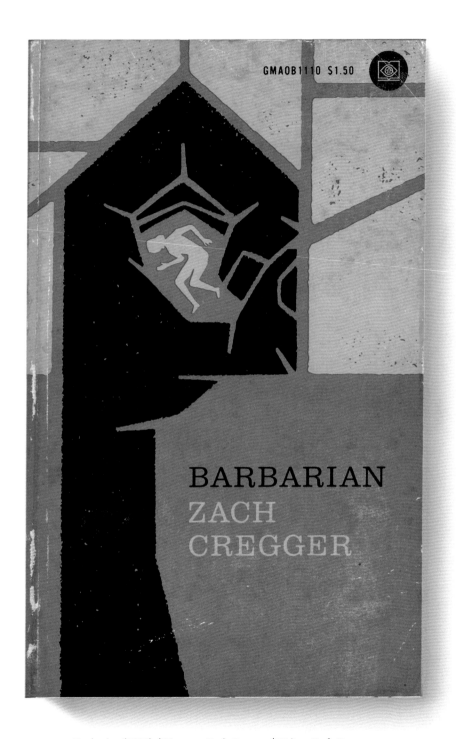

GMAOB1110 $1.50

BARBARIAN
ZACH
CREGGER

Barbarian (2022) / Director: Zach Cregger / Writer: Zach Cregger

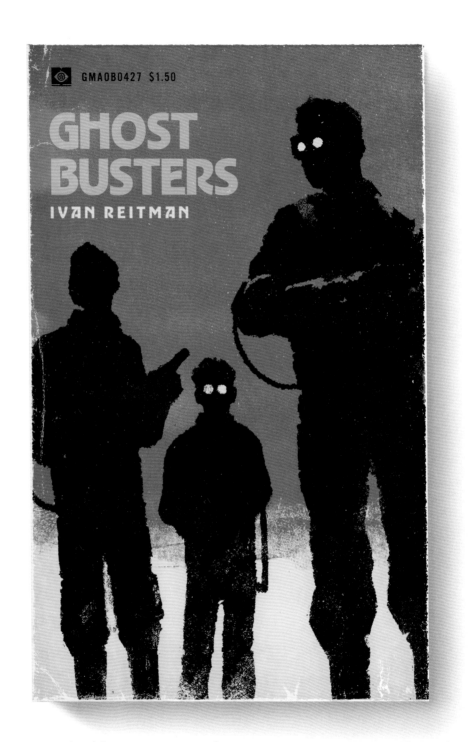

Within the cover image:

GMAOB0427 $1.50

GHOST
BUSTERS

IVAN REITMAN

Ghostbusters (1984) / Director: Ivan Reitman / Writers: Dan Aykroyd, Harold Ramis, Rick Moranis

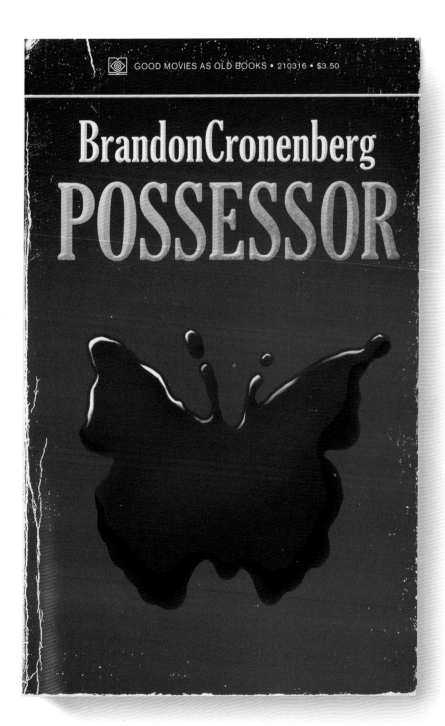

BrandonCronenberg
POSSESSOR

Possessor (2020) / Director: Brandon Cronenberg / Writer: Brandon Cronenberg

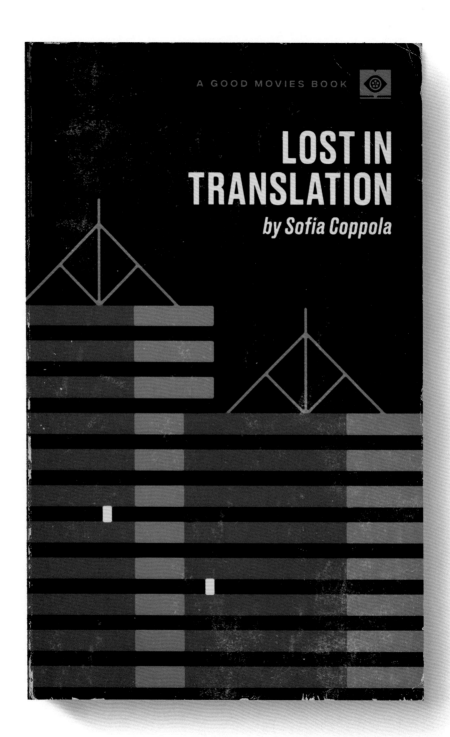

Lost in Translation (2003) / Director: Sofia Coppola / Writer: Sofia Coppola

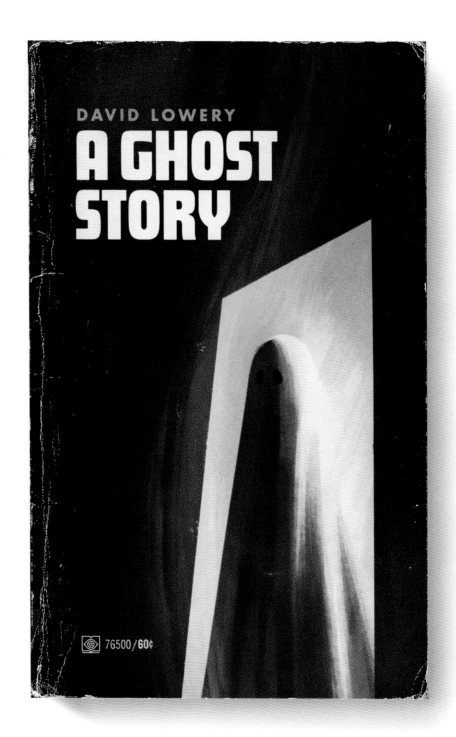

A Ghost Story (2017) / Director: David Lowery / Writer: David Lowery

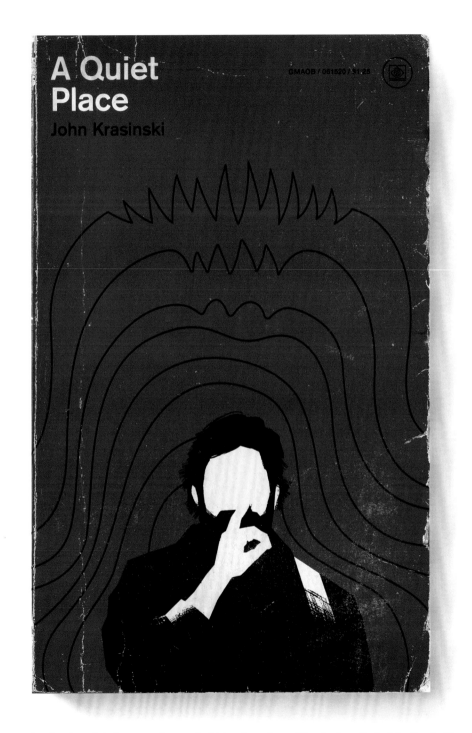

A Quiet Place (2018) / Director: John Krasinski / Writers: Bryan Woods, Scott Beck, John Krasinski

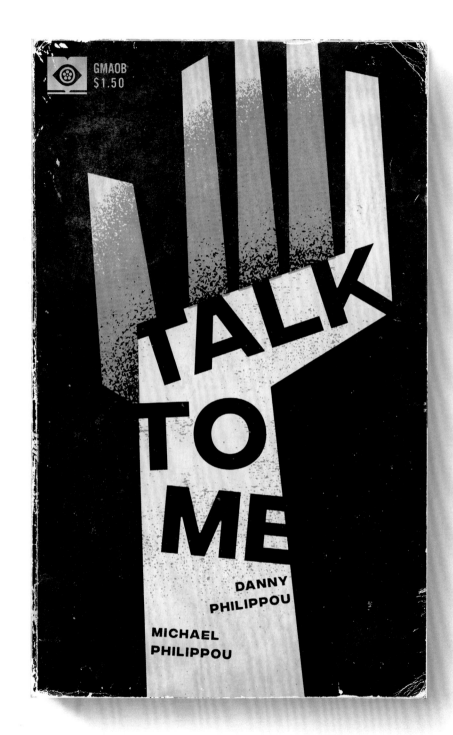

Talk to Me (2022) / Directors: Danny Philippou, Michael Philippou
Writers: Danny Philippou, Bill Hinzman, Daley Pearson

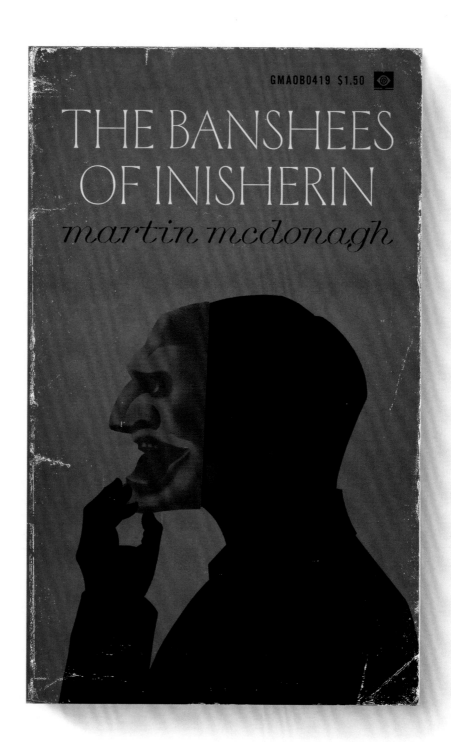

THE BANSHEES
OF INISHERIN

martin mcdonagh

GMAOB0419 $1.50

The Banshees of Inisherin (2022) / Director: Martin McDonagh / Writer: Martin McDonagh

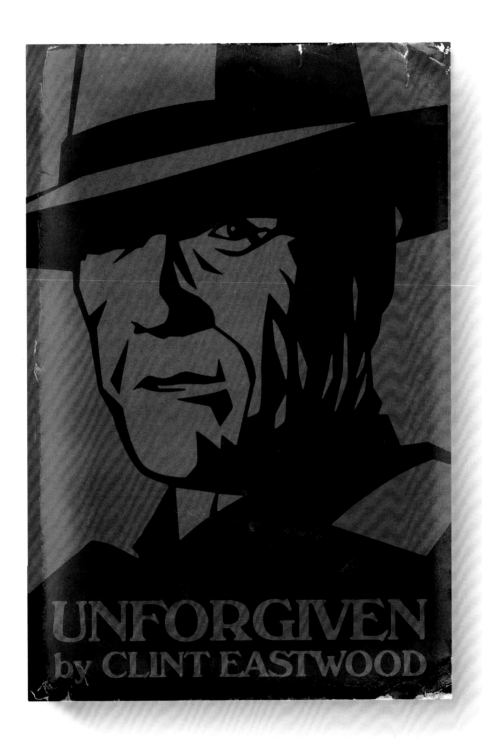

Unforgiven (1992) / Director: Clint Eastwood / Writer: David Webb Peoples

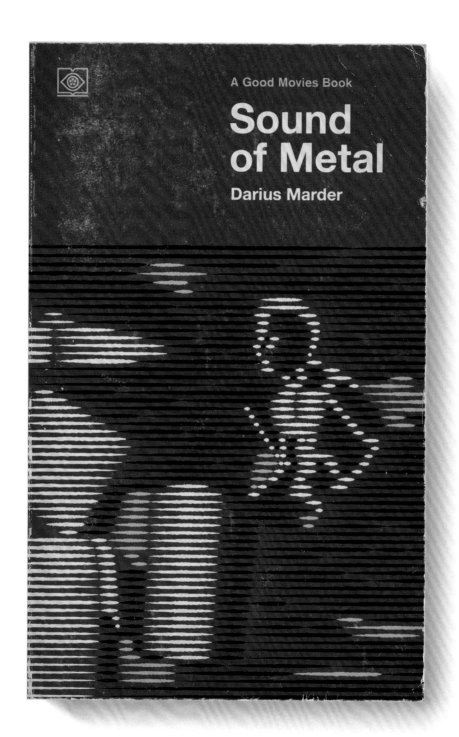

A Good Movies Book

Sound of Metal

Darius Marder

Sound of Metal (2019) / Director: Darius Marder / Writers: Darius Marder, Abraham Marder
Original Concept: Derek Cianfrance

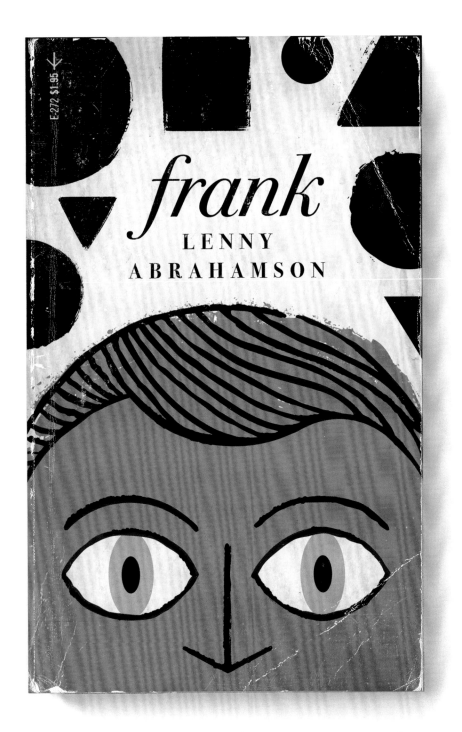

Frank (2014) / Director: Lenny Abrahamson / Writers: Jon Ronson, Peter Straughan

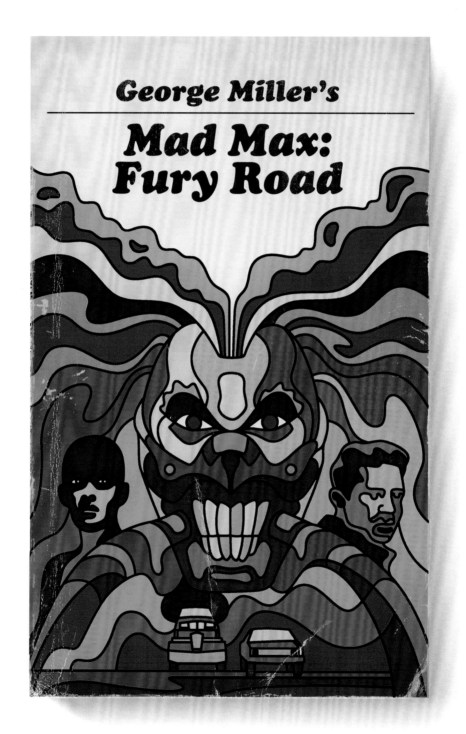

Mad Max: Fury Road (2015) / Director: George Miller
Writers: George Miller, Brendan McCarthy, Nick Lathouris

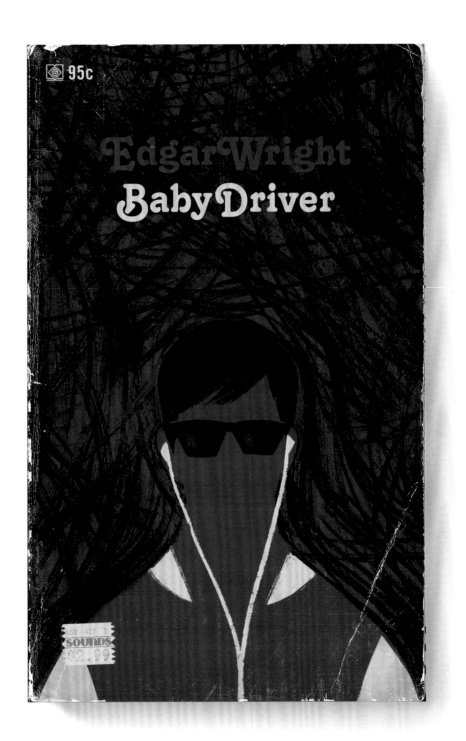

Baby Driver (2017) / Director: Edgar Wright / Writer: Edgar Wright

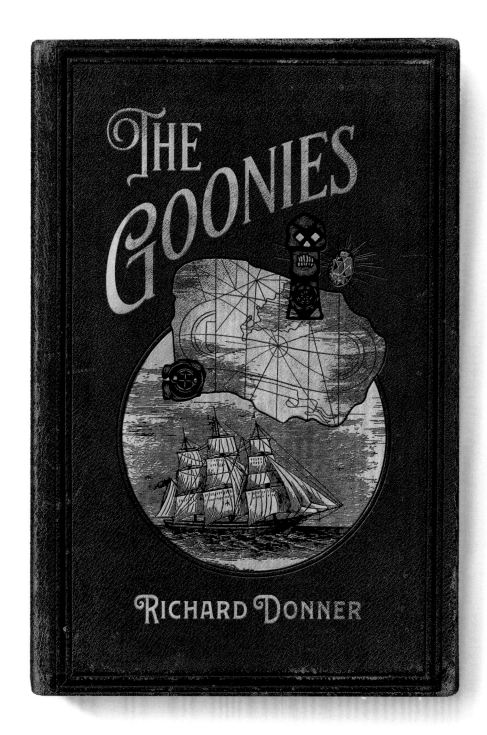

The Goonies (1985) / Director: Richard Donner / Writers: Chris Columbus, Steven Spielberg

THE
GOONIES

RICHARD DONNER

MCMLXXXV

Iusiurandum tolle. Adiungere Adventum

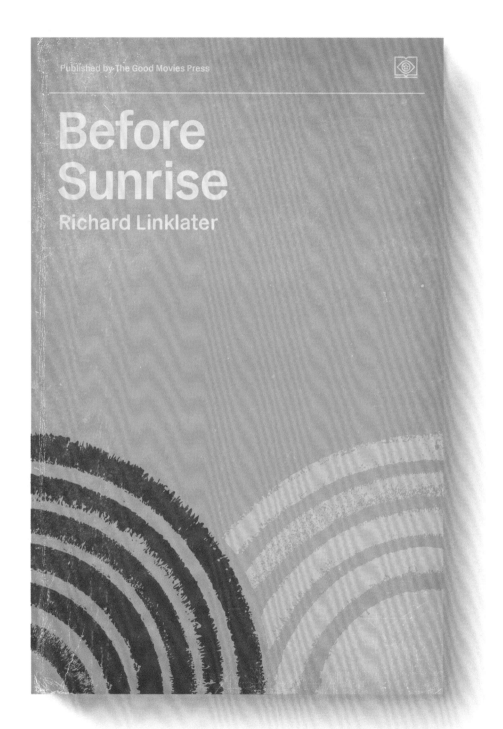

Before Sunrise (1995) / Director: Richard Linklater / Writers: Richard Linklater, Kim Krizan

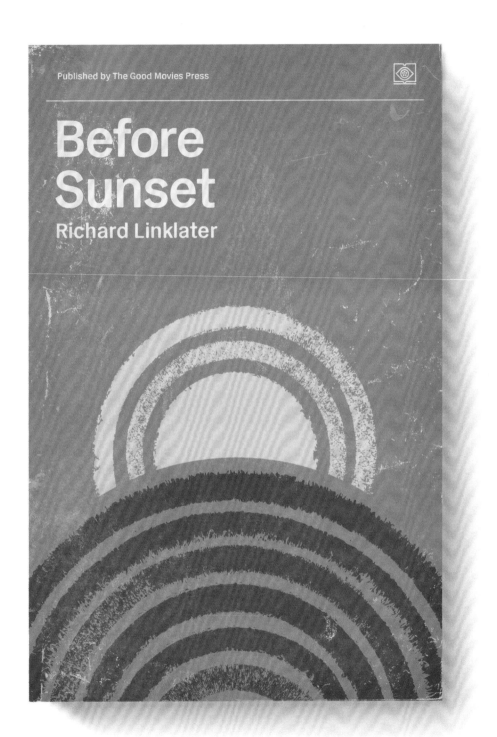

Published by The Good Movies Press

Before Sunset

Richard Linklater

Before Sunset (2004) / Director: Richard Linklater
Writers: Richard Linklater, Julie Delpy, Ethan Hawke, Kim Krizan

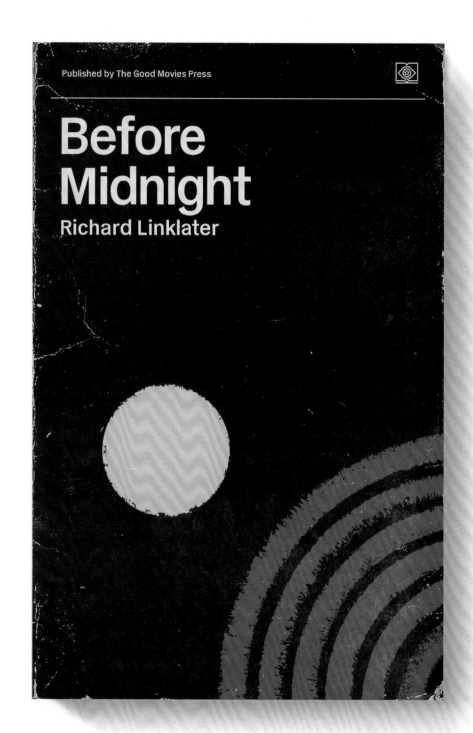

Before Midnight (2014) / Director: Richard Linklater
Writers: Richard Linklater, Julie Delpy, Ethan Hawke, Kim Krizan

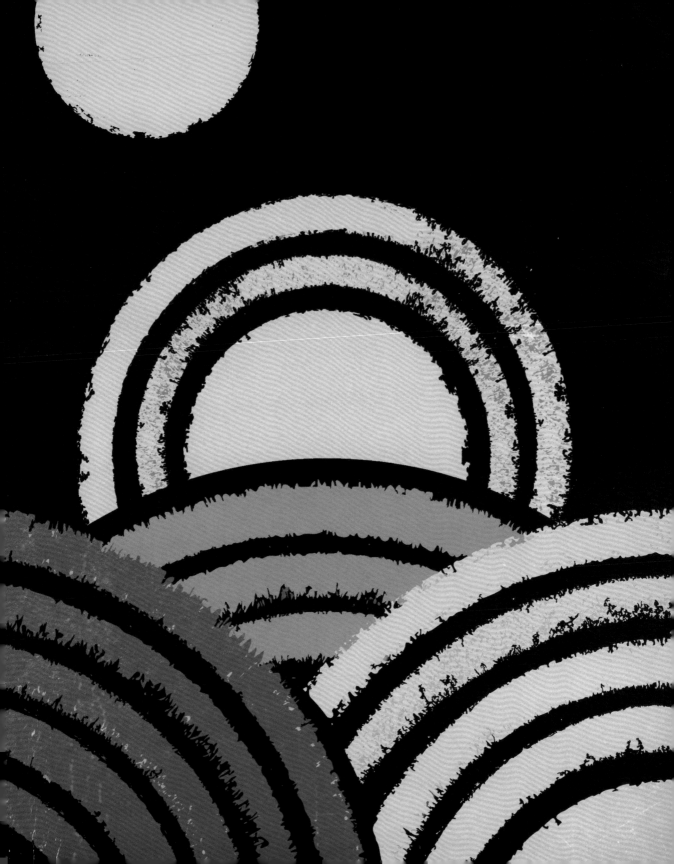

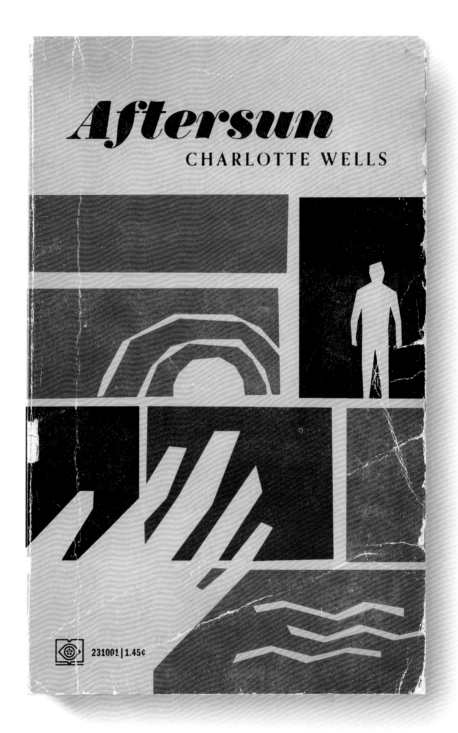

231001 | 1.45¢

Aftersun (2022) / Director: Charlotte Wells / Writer: Charlotte Wells

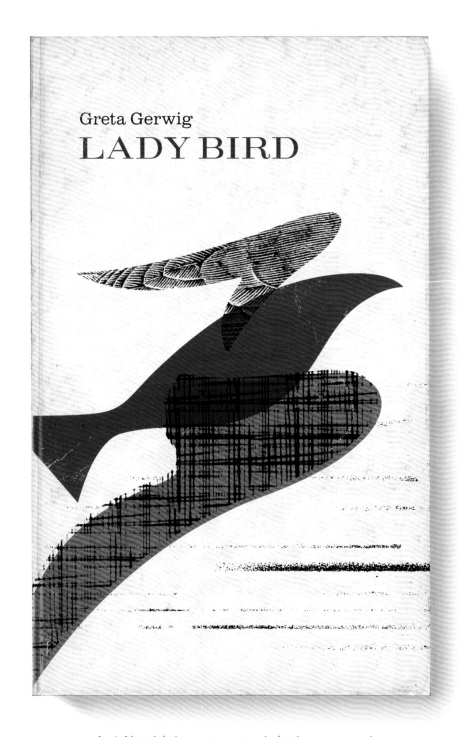

Lady Bird (2017) / Director: Greta Gerwig / Writer: Greta Gerwig

42 *Uncut Gems* (2019) / Directors: Benny Safdie, Josh Safdie / Writers: Ronald Bronstein, Josh Safdie, Benny Safdie

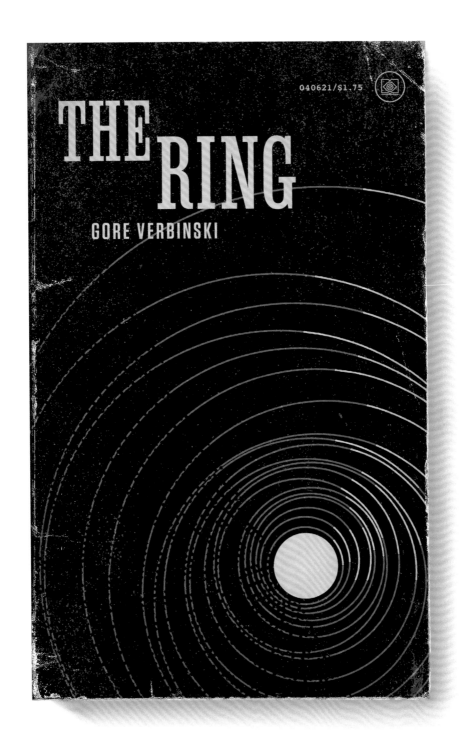

THE RING

GORE VERBINSKI

040621/$1.75

The Ring (2002) / Director: Gore Verbinski / Writer: Ehren Kruger
Original Screenplay (1998): Hiroshi Takahashi / Original Novel: Koji Suzuki

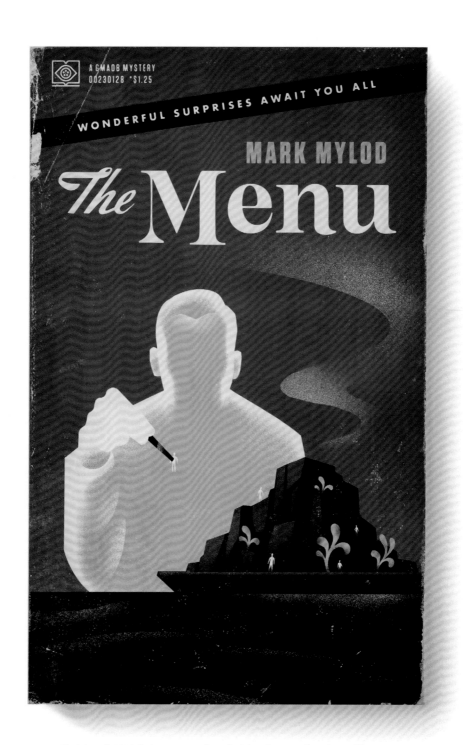

The Menu (2022) / Director: Mark Mylod / Writers: Seth Reiss, Will Tracy

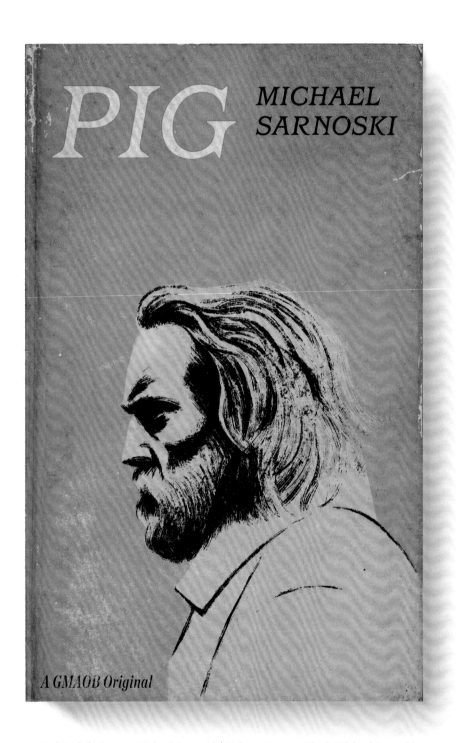

PIG

MICHAEL SARNOSKI

A GMAOB Original

Pig (2021) / Director: Michael Sarnoski / Writers: Vanessa Block, Michael Sarnoski

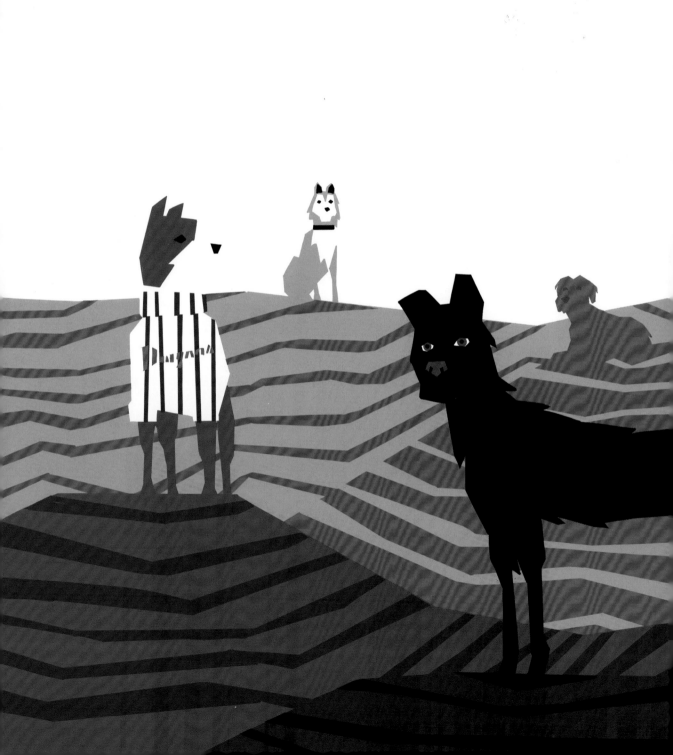

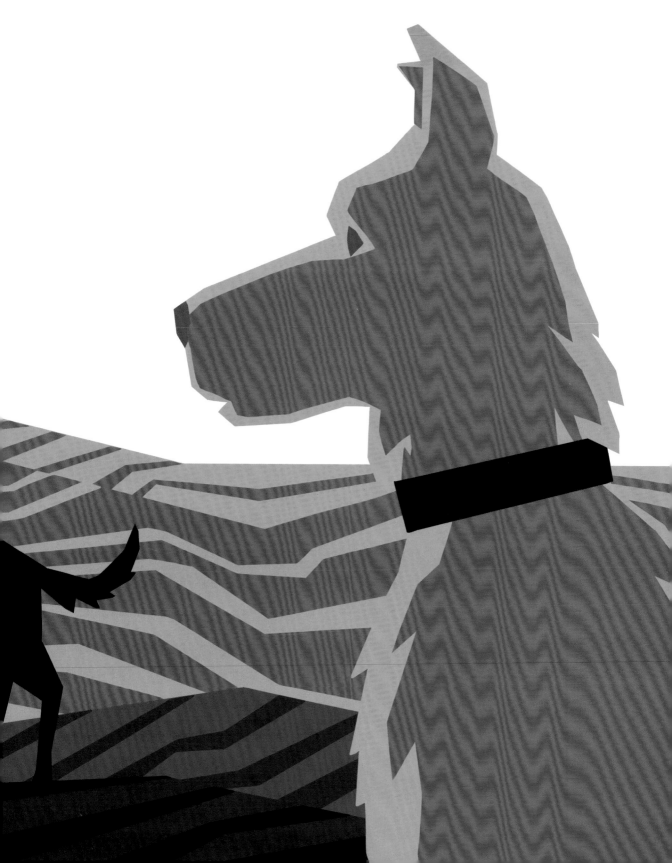

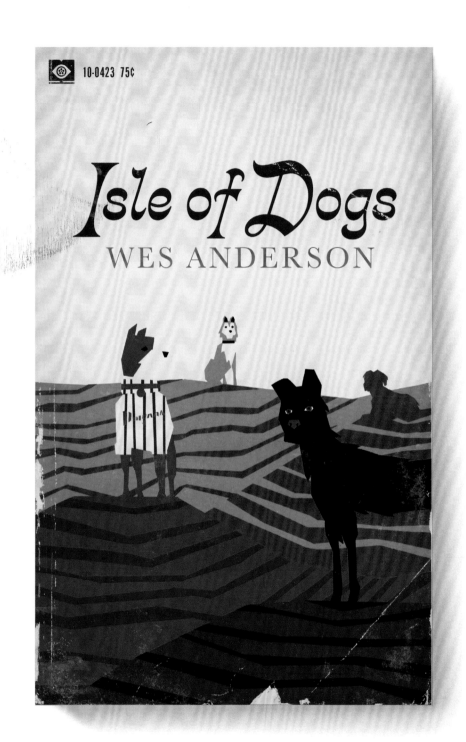

10-0423 75¢

Isle of Dogs
WES ANDERSON

Isle of Dogs (2018) / Director: Wes Anderson / Writers: Wes Anderson, Roman Coppola, Jason Schwartzman

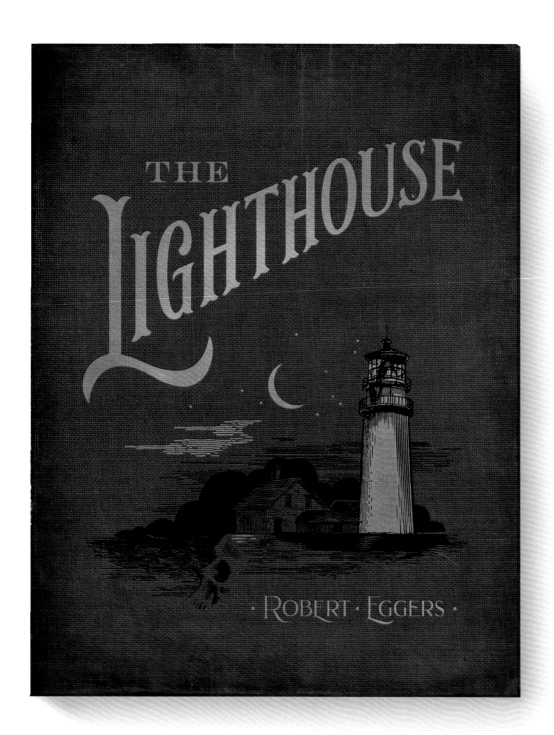

The Lighthouse (2019) / Director: Robert Eggers / Writers: Robert Eggers, Max Eggers

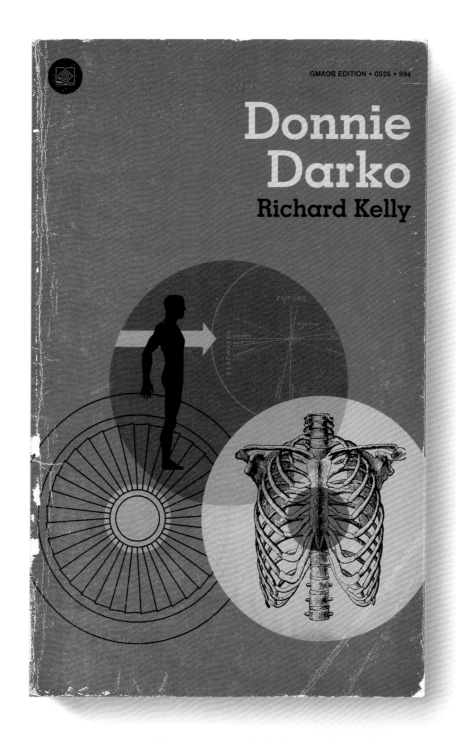

Donnie Darko

Richard Kelly

Donnie Darko (2001) / Director: Richard Kelly / Writer: Richard Kelly

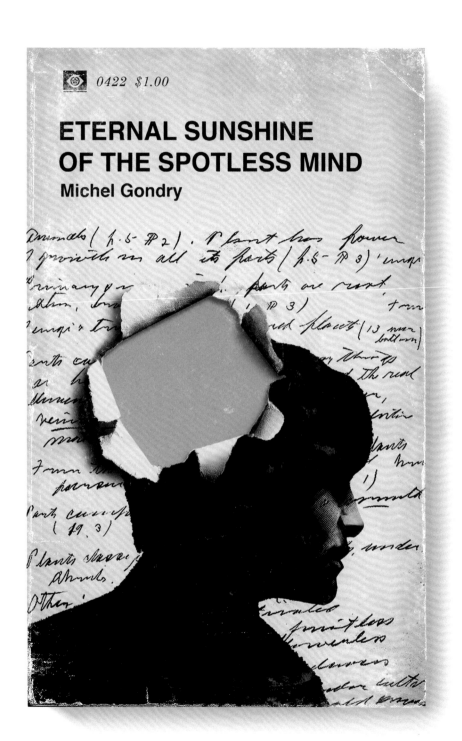

Eternal Sunshine of the Spotless Mind (2004) / Director: Michel Gondry
Writers: Charlie Kaufman, Michel Gondry, Pierre Bismuth

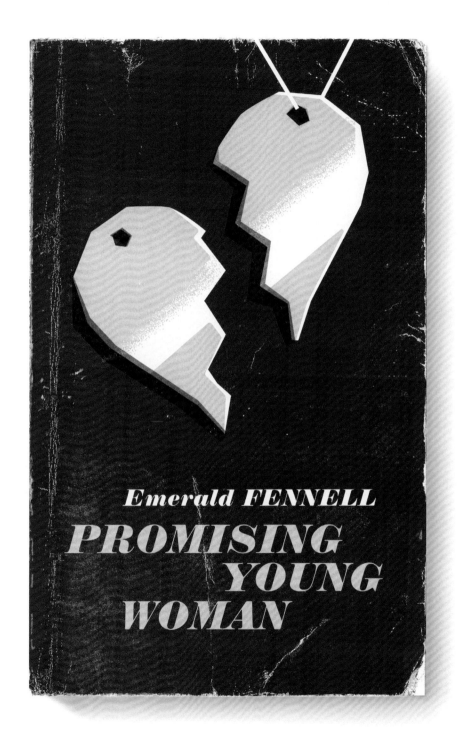

Emerald FENNELL

PROMISING
YOUNG
WOMAN

Promising Young Woman (2020) / Director: Emerald Fennell / Writer: Emerald Fennell

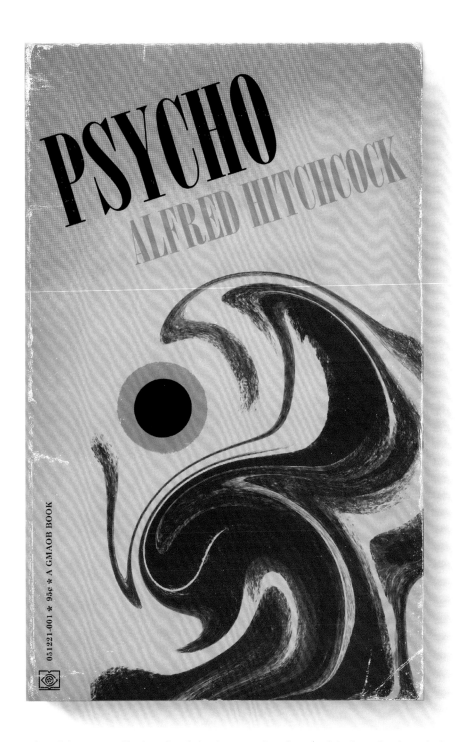

On the cover:

PSYCHO

ALFRED HITCHCOCK

051221-001 ✲ 95¢ ✲ A GMAOB BOOK

Psycho (1960) / Director: Alfred Hitchcock / Writer: Joseph Stefano / Original Novel: Robert Bloch

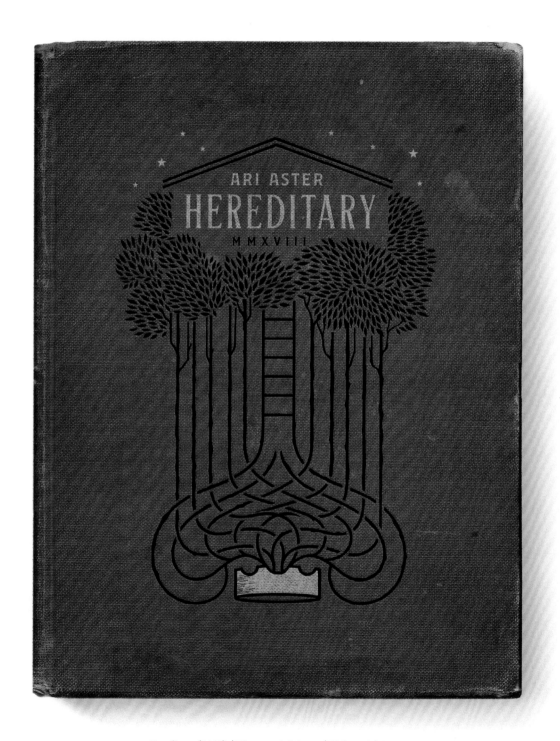

Hereditary (2018) / Director: Ari Aster / Writer: Ari Aster

HEREDITARY

BY

ARI ASTER

· MMXVIII ·

Omnis Arbor Familiae Secretum Abscondit.

40.7608° N, 111.8910° W

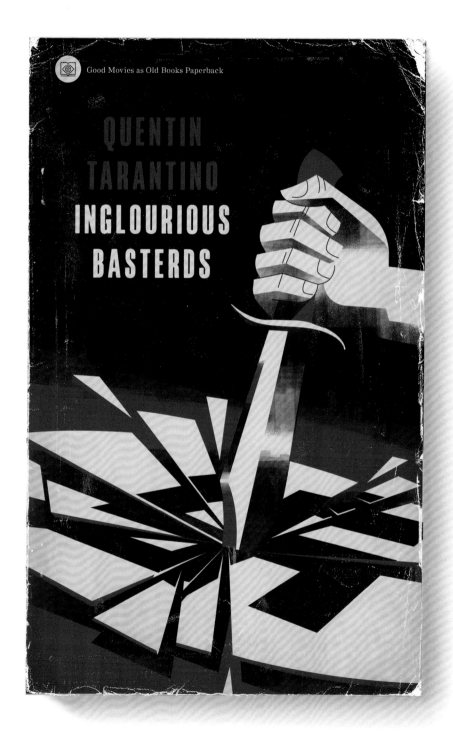

Inglourious Basterds (2009) / Director: Quentin Tarantino / Writer: Quentin Tarantino

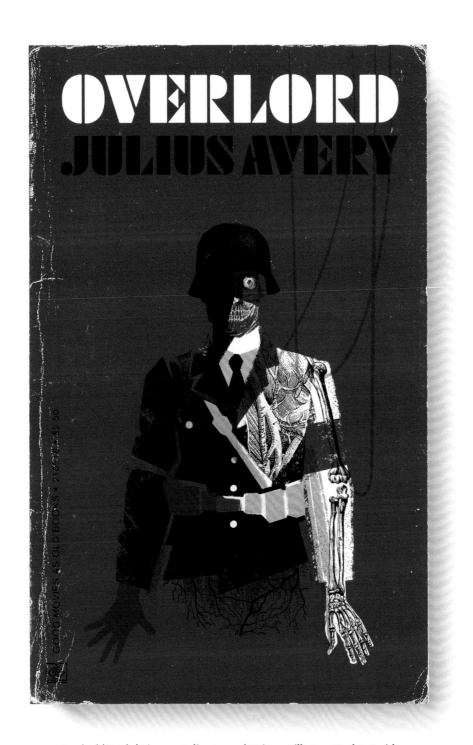

Overlord (2018) / Director: Julius Avery / Writers: Billy Ray, Mark L. Smith

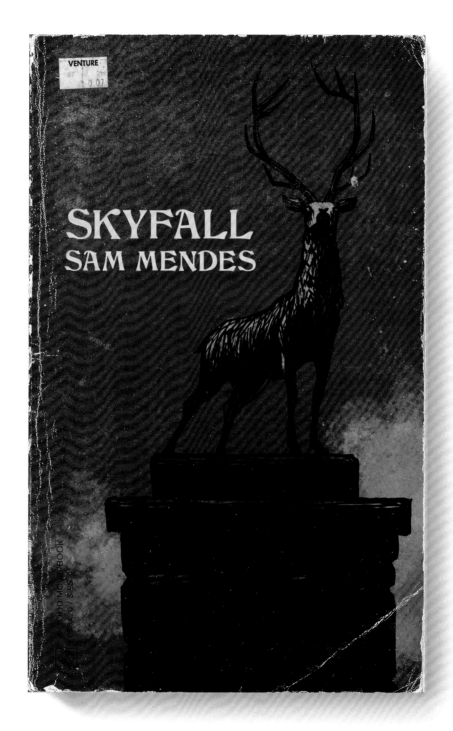

Skyfall (2012) / Director: Sam Mendes / Writers: Neal Purvis, Robert Wade, John Logan
Original Characters: Ian Fleming

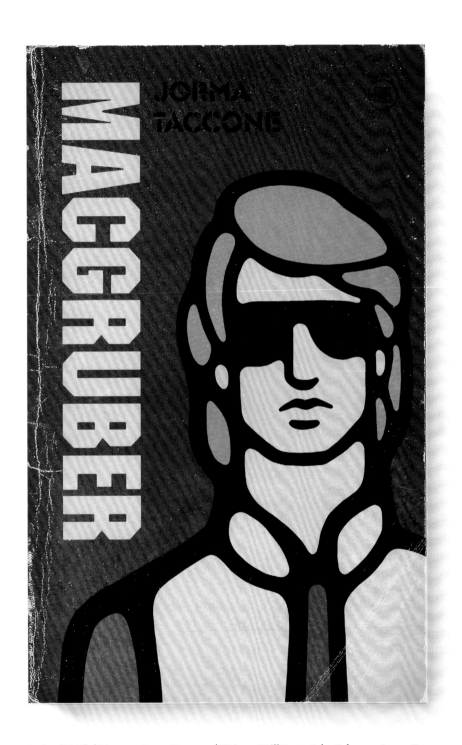

MacGruber (2010) / Director: Jorma Taccone / Writers: Will Forte, John Solomon, Jorma Taccone

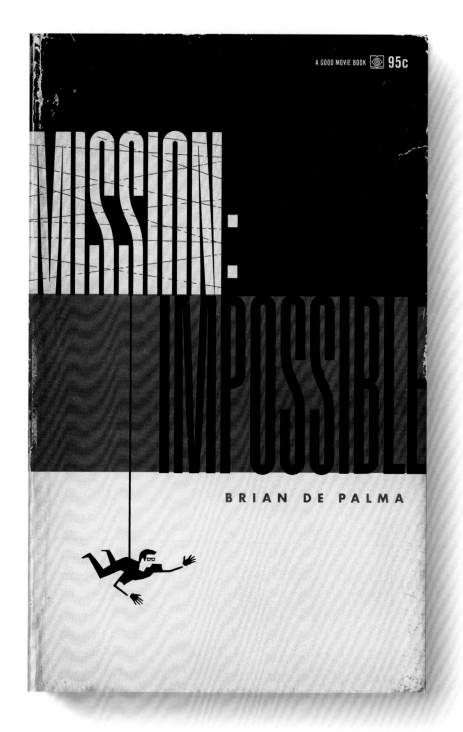

Mission: Impossible (1996) / Director: Brian De Palma
Writers: David Koepp, Steven Zaillian, Robert Towne / Original TV Series: Bruce Geller

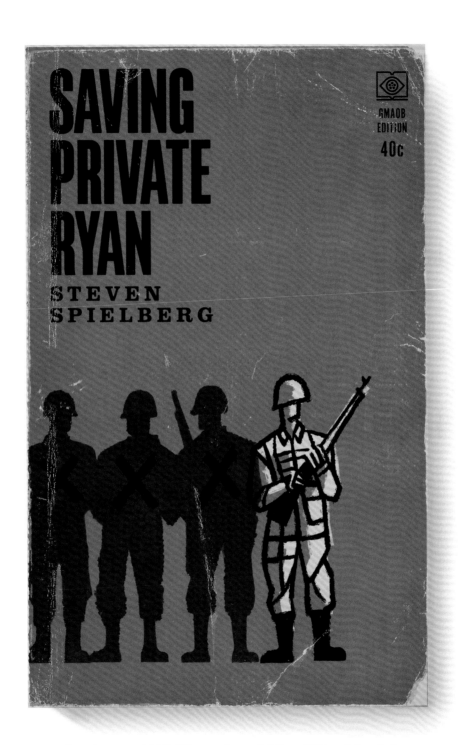

Saving Private Ryan (1998) / Director: Steven Spielberg / Writer: Robert Rodat

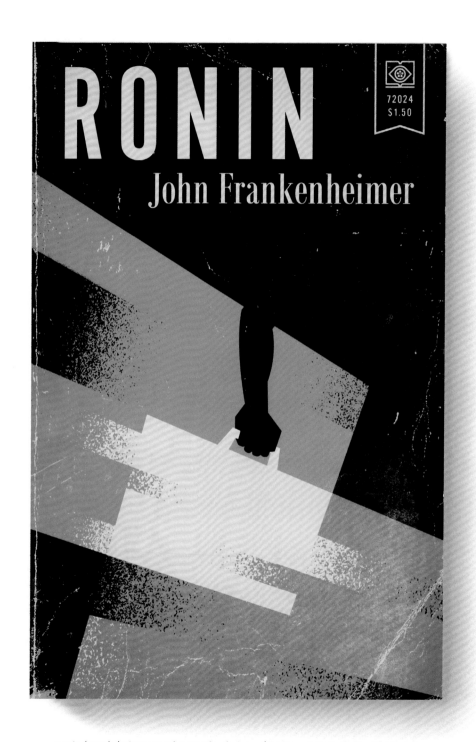

Ronin (1998) / Director: John Frankenheimer / Writers: J. D. Zeik, David Mamet

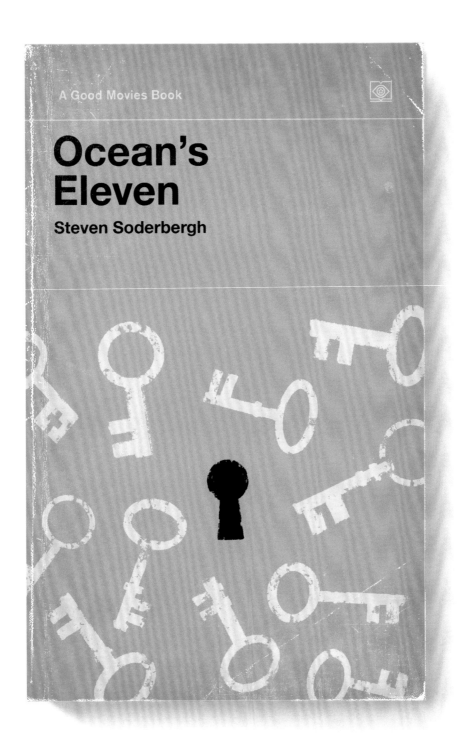

Ocean's Eleven (2001) / Director: Steven Soderbergh / Writer: Ted Griffin

Original Screenplay (1960): George Clayton Johnson, Jack Golden Russell, Harry Brown, Charles Lederer

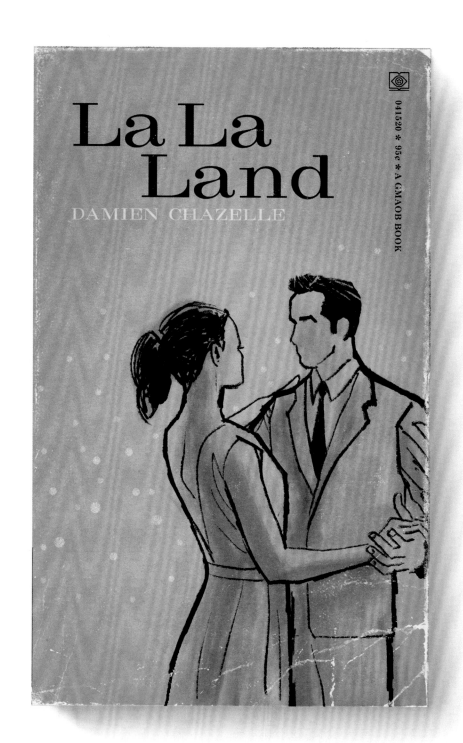

La La Land

DAMIEN CHAZELLE

041520 ✲ 95¢ ✲ A GMAOB BOOK

La La Land (2016) / Director: Damien Chazelle / Writer: Damien Chazelle

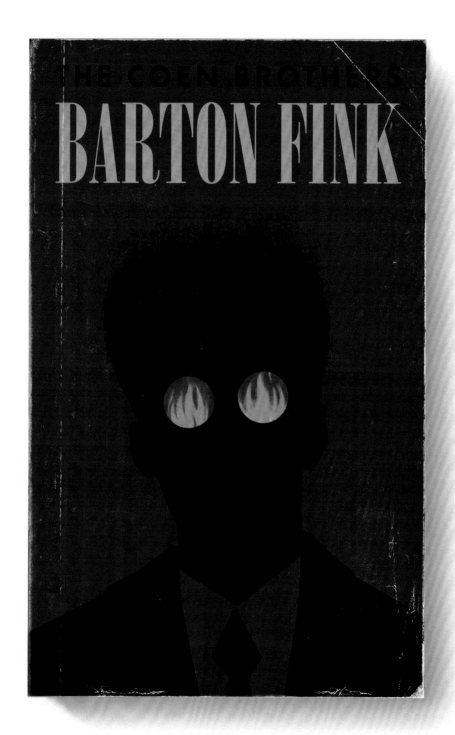

Barton Fink (1991) / Directors: Joel Coen, Ethan Coen / Writers: Joel Coen, Ethan Coen

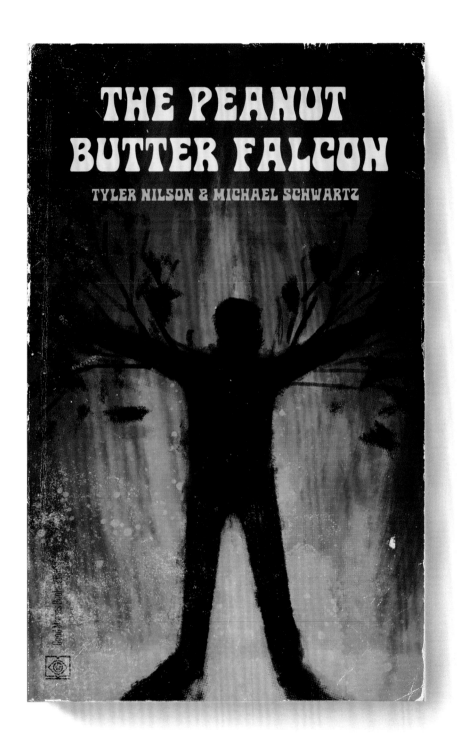

The Peanut Butter Falcon (2019) / Directors: Tyler Nilson, Michael Schwartz

Writers: Tyler Nilson, Michael Schwartz

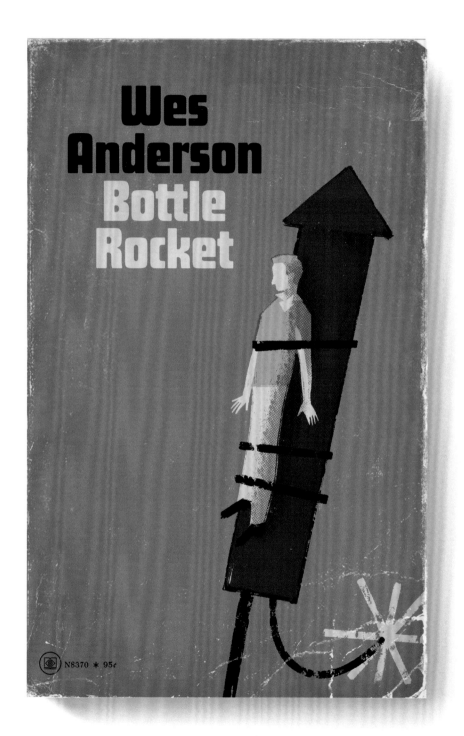

Bottle Rocket (1996) / Director: Wes Anderson / Writers: Wes Anderson, Owen Wilson

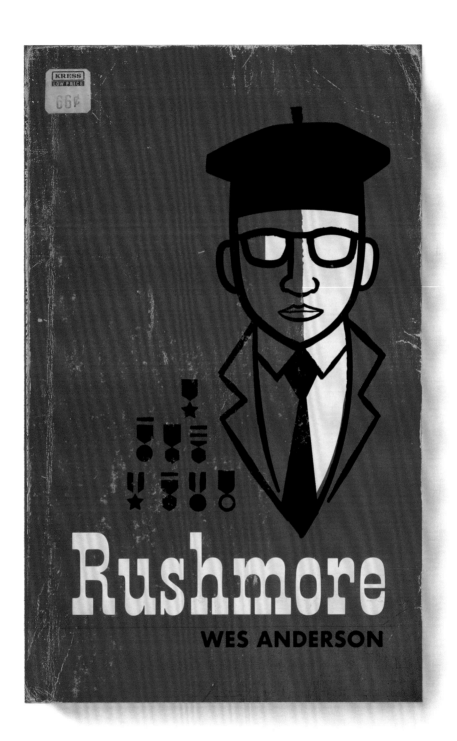

Rushmore (1998) / Director: Wes Anderson / Writers: Wes Anderson, Owen Wilson

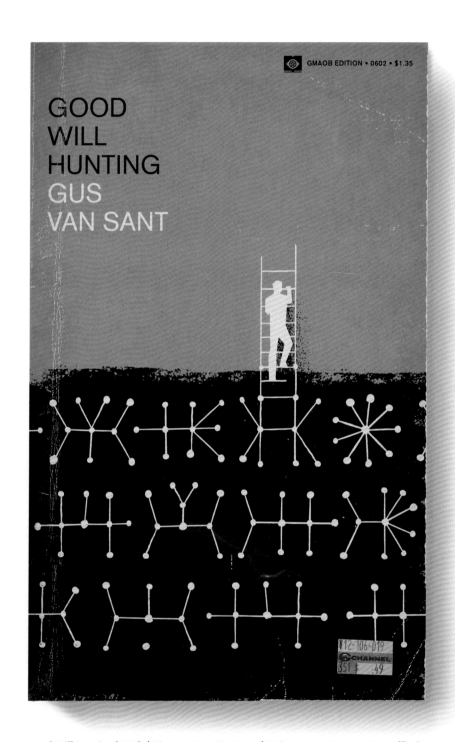

GMAOB EDITION • 0602 • $1.35

GOOD
WILL
HUNTING
GUS
VAN SANT

Good Will Hunting (1997) / Director: Gus Van Sant / Writers: Matt Damon, Ben Affleck

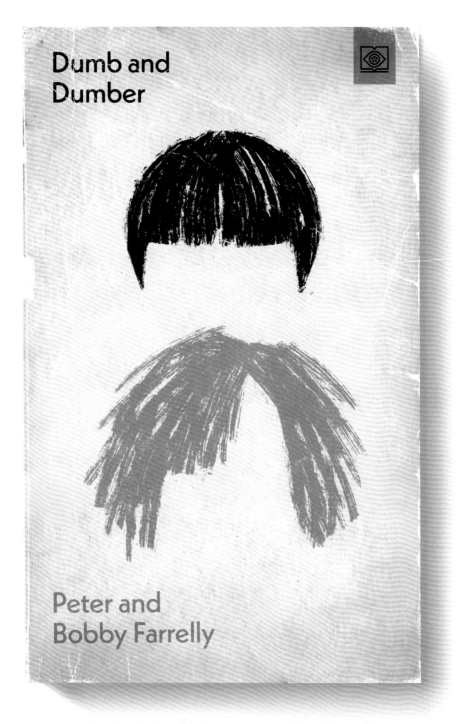

Dumb and Dumber (1994) / Directors: Peter Farrelly, Bobby Farrelly
Writers: Peter Farrelly, Bennett Yellin, Bobby Farrelly

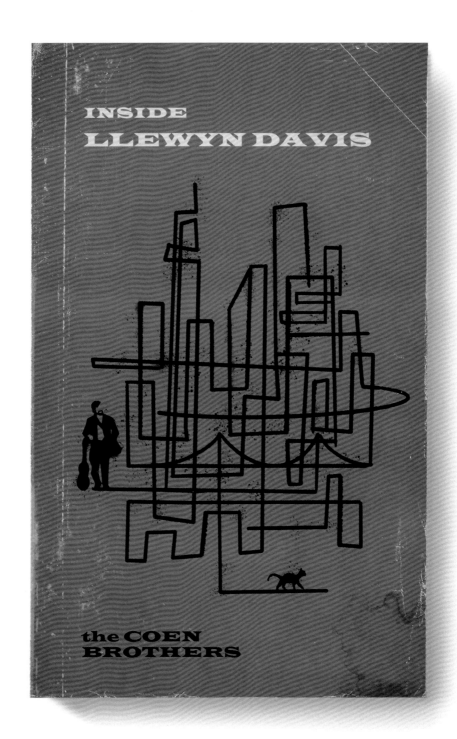

Inside Llewyn Davis (2013) / Directors: Joel Coen, Ethan Coen / Writers: Joel Coen, Ethan Coen

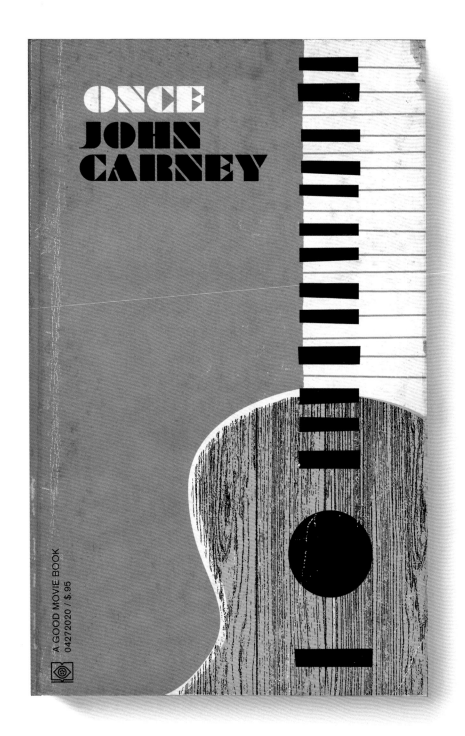

ONCE
JOHN CARNEY

A GOOD MOVIE BOOK
04272020 / $.95

Once (2007) / Director: John Carney / Writer: John Carney

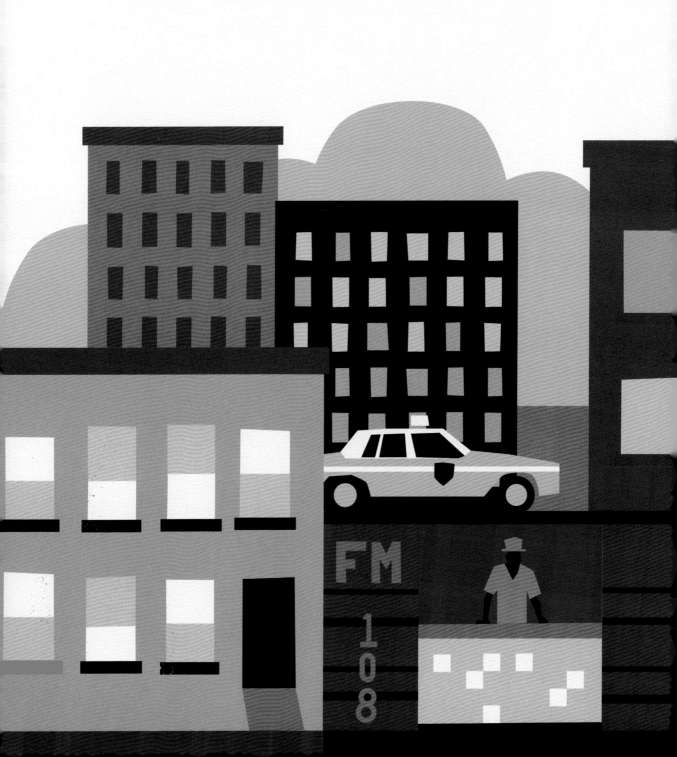

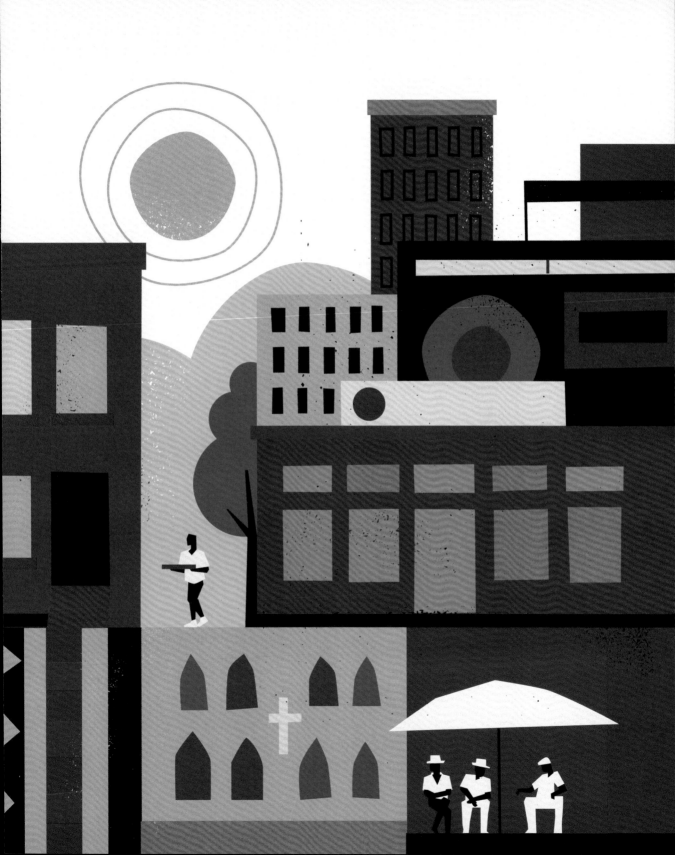

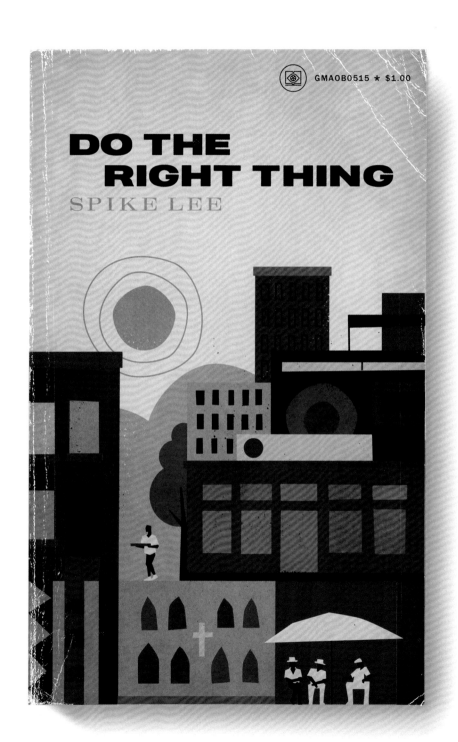

GMAOB0515 ★ $1.00

DO THE RIGHT THING

SPIKE LEE

Do the Right Thing (1989) / Director: Spike Lee / Writer: Spike Lee

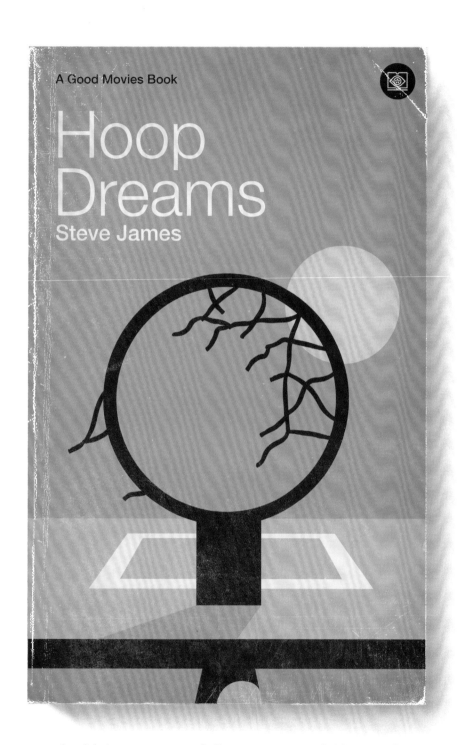

A Good Movies Book

Hoop Dreams

Steve James

Hoop Dreams (1994) / Director: Steve James / Editors: Steve James, Frederick Marx, William Haugse

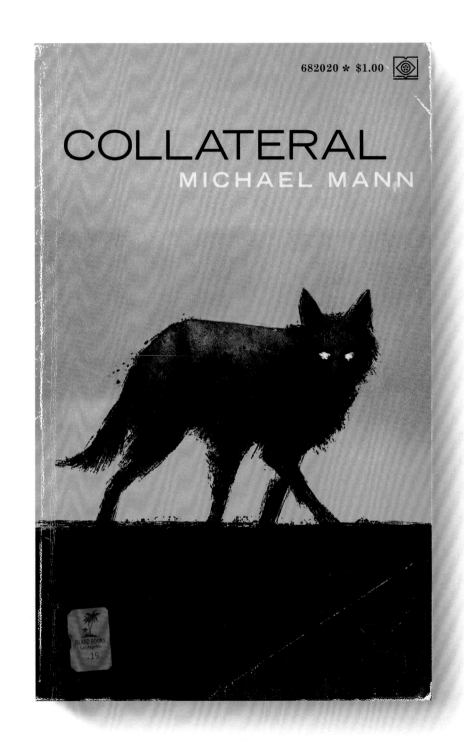

682020 * $1.00

COLLATERAL

MICHAEL MANN

ISLAND BOOKS
Los Angeles
.19

Collateral (2004) / Director: Michael Mann / Writer: Stuart Beattie

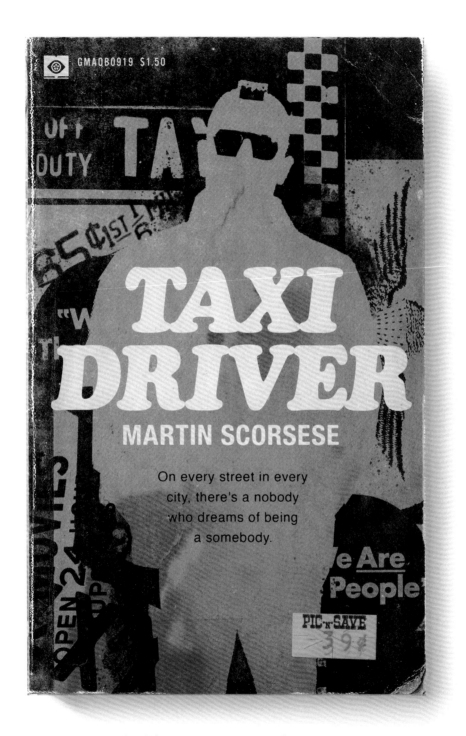

Taxi Driver (1976) / Director: Martin Scorsese / Writer: Paul Schrader

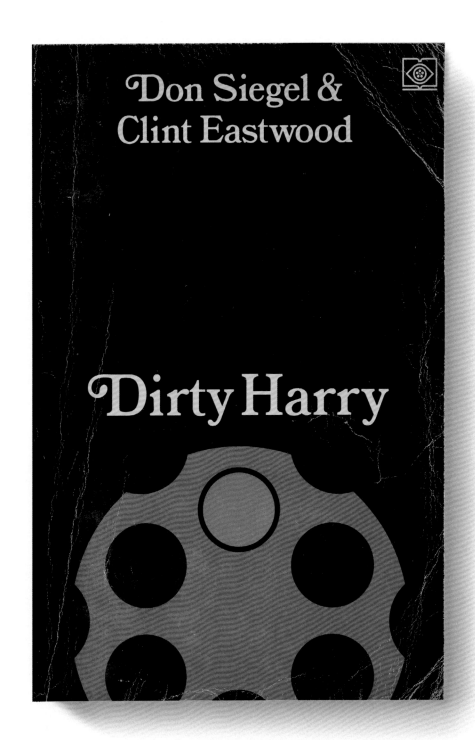

Dirty Harry (1971) / Directors: Don Siegel, Clint Eastwood / Writers: Harry Julian Fink, Rita M. Ford, Dean Riesner, Terrence Malick (uncredited), Jo Heims (uncredited), John Milius (uncredited)

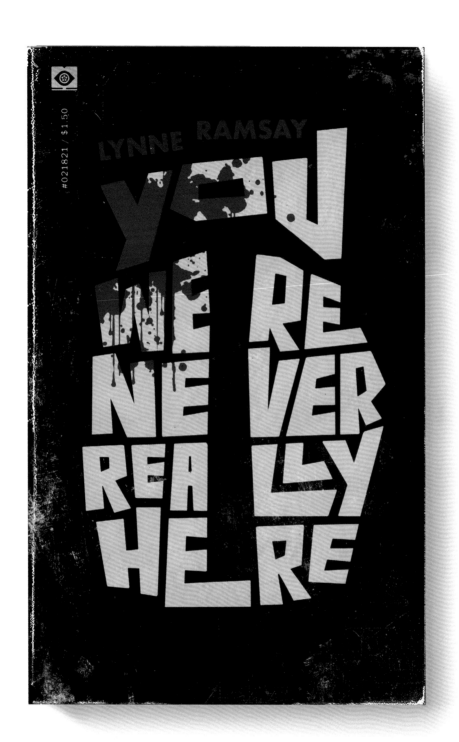

You Were Never Really Here (2017) / Director: Lynne Ramsay / Writers: Lynne Ramsay, Jonathan Ames

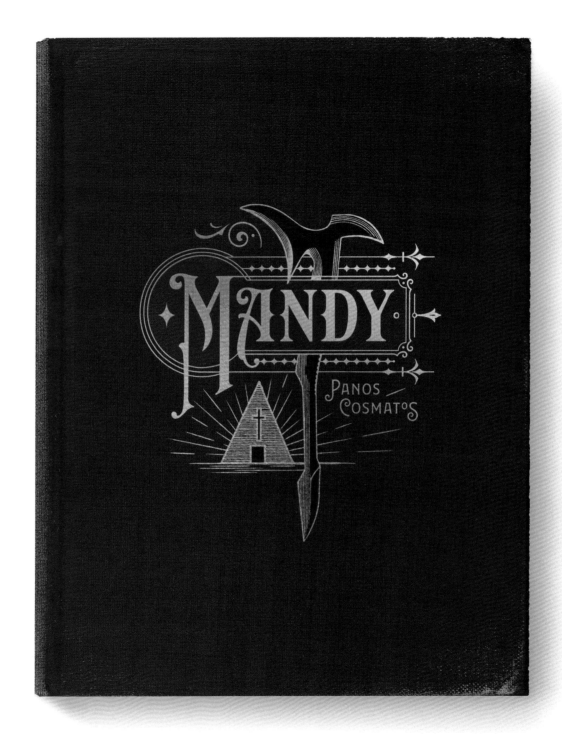

Mandy (2018) / Director: Panos Cosmatos / Writers: Panos Cosmatos, Aaron Stewart-Ahn, Casper Kelly

MANDY

MMXVIII

QUOM MORI, SEPELITE ME

BY

PANOS COSMATOS

LONDON

PRINTED FOR THE AUTHOR

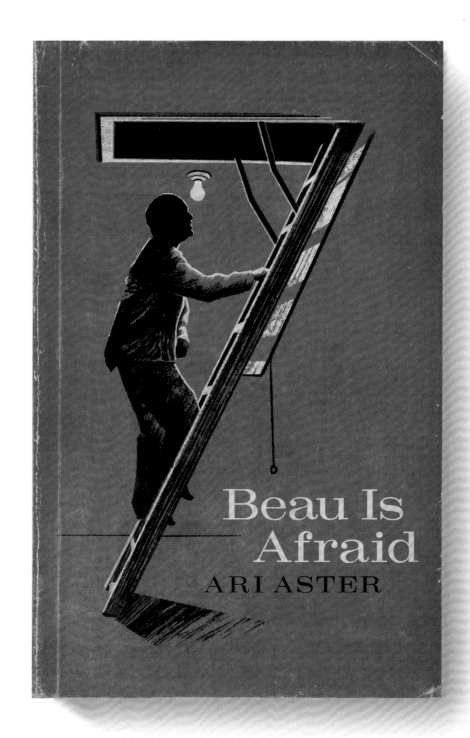

Beau Is Afraid

ARI ASTER

Beau Is Afraid (2023) / Director: Ari Aster / Writer: Ari Aster

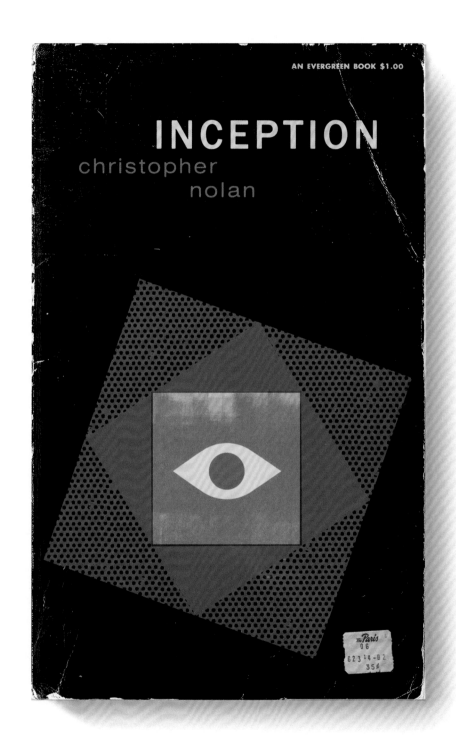

Inception (2010) / Director: Christopher Nolan / Writer: Christopher Nolan

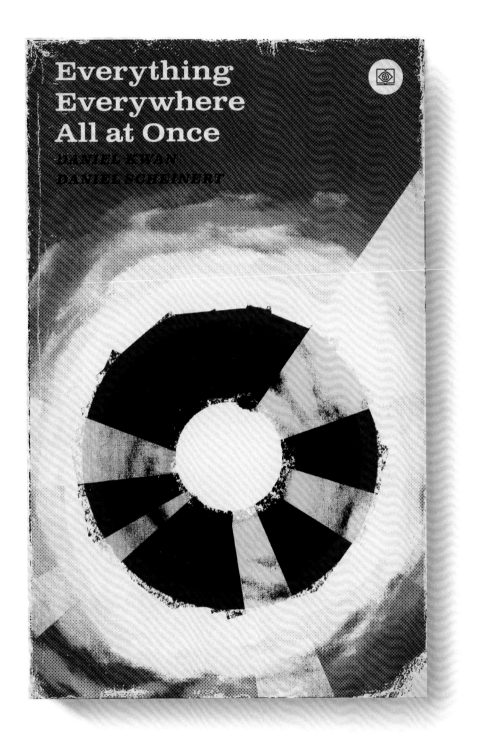

Everything Everywhere All at Once (2022) / Directors: Daniel Kwan, Daniel Scheinert
Writers: Daniel Kwan, Daniel Scheinert

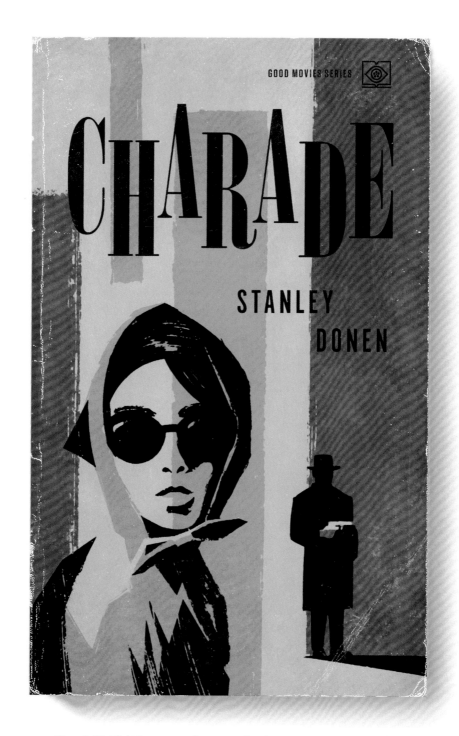

CHARADE

STANLEY DONEN

Charade (1963) / Director: Stanley Donen / Writers: Peter Stone, Marc Behm

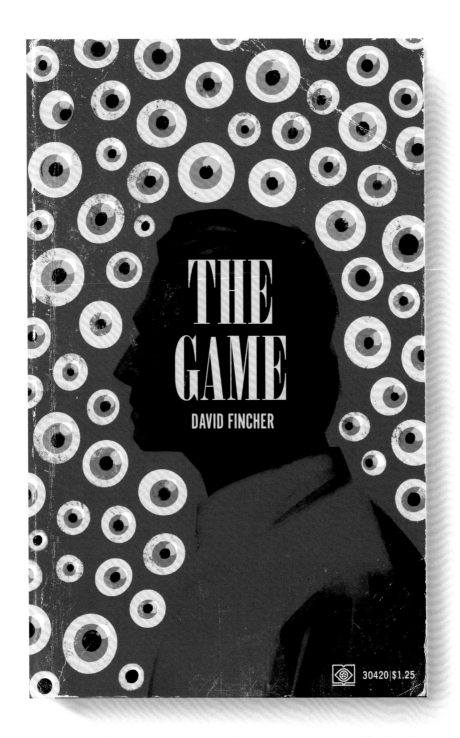

The Game (1997) / Director: David Fincher / Writers: John Brancato, Michael Ferris

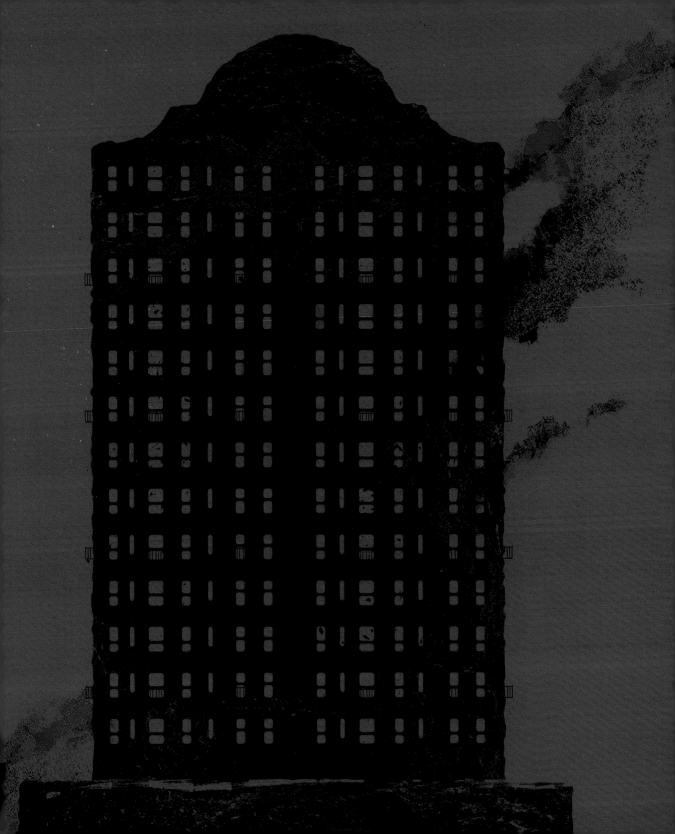

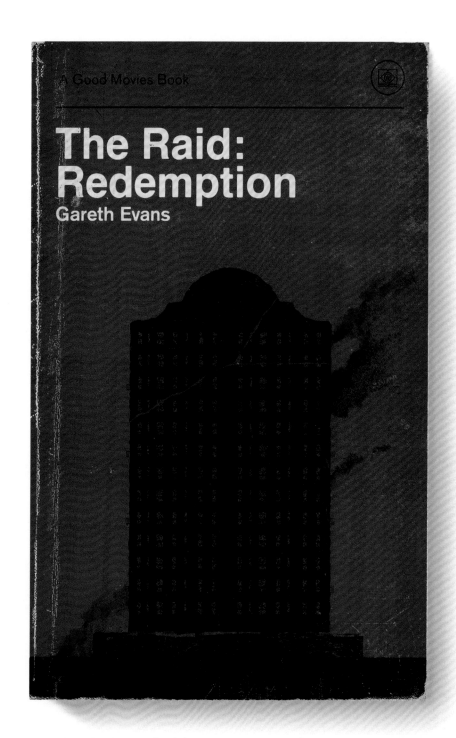

A Good Movies Book

The Raid: Redemption

Gareth Evans

The Raid: Redemption (2011) / Director: Gareth Evans / Writer: Gareth Evans

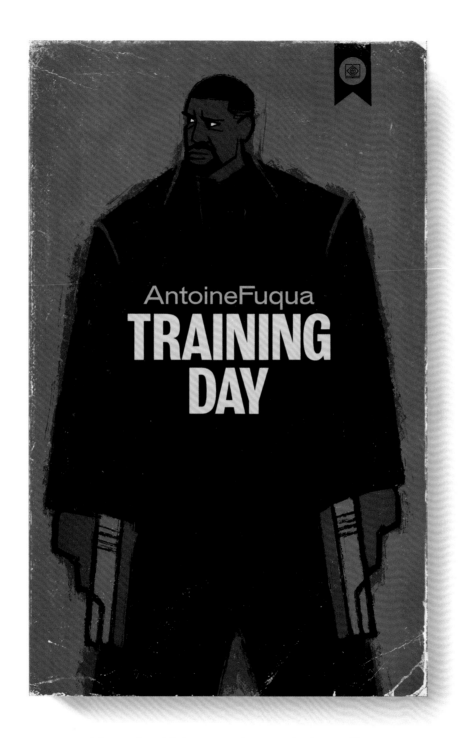

AntoineFuqua

TRAINING DAY

Training Day (2001) / Director: Antoine Fuqua / Writer: David Ayer

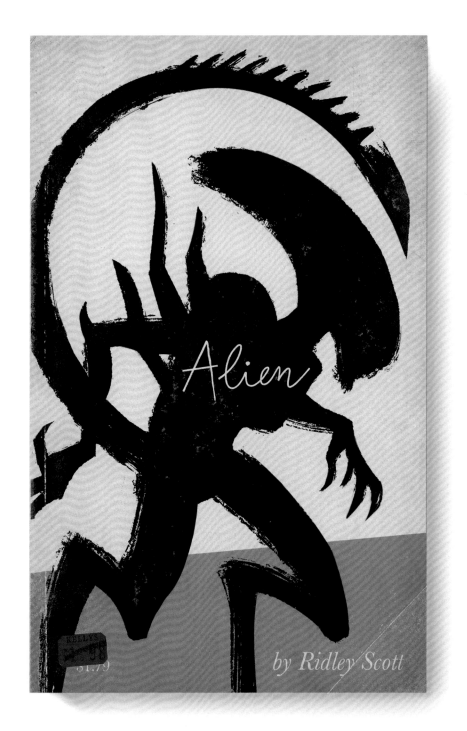

Alien (1979) / Director: Ridley Scott / Writers: Dan O'Bannon, Ronald Shusett

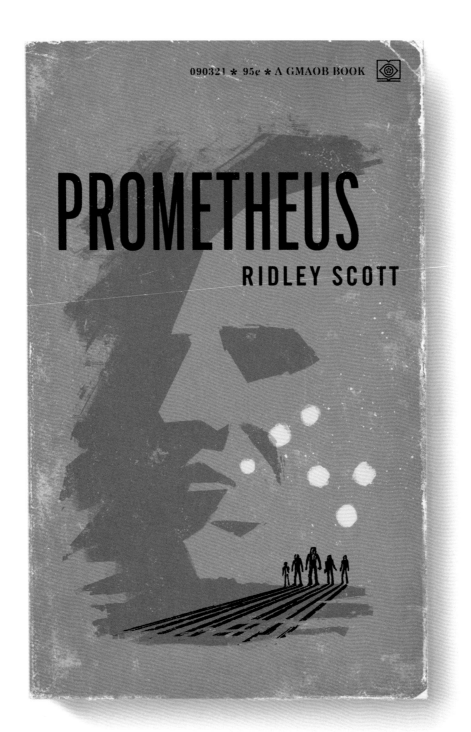

Prometheus (2012) / Director: Ridley Scott / Writers: Jon Spaihts, Damon Lindelof, Dan O'Bannon

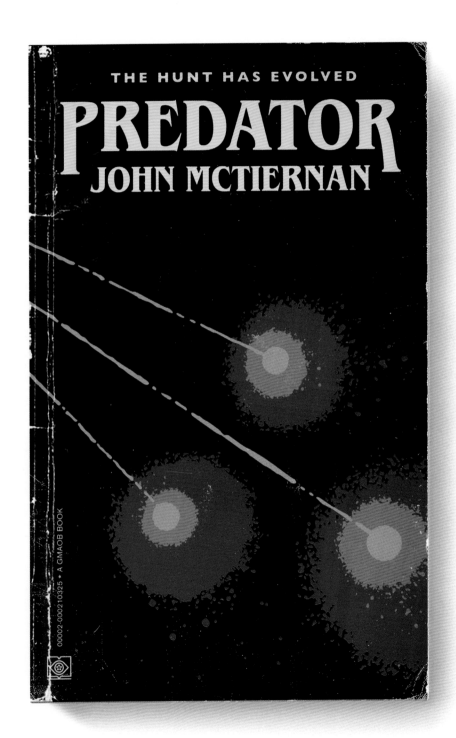

THE HUNT HAS EVOLVED

PREDATOR
JOHN MCTIERNAN

00002-000210325 ★ A GMAOB BOOK

Predator (1987) / Director: John McTiernan / Writers: Jim Thomas, John Thomas

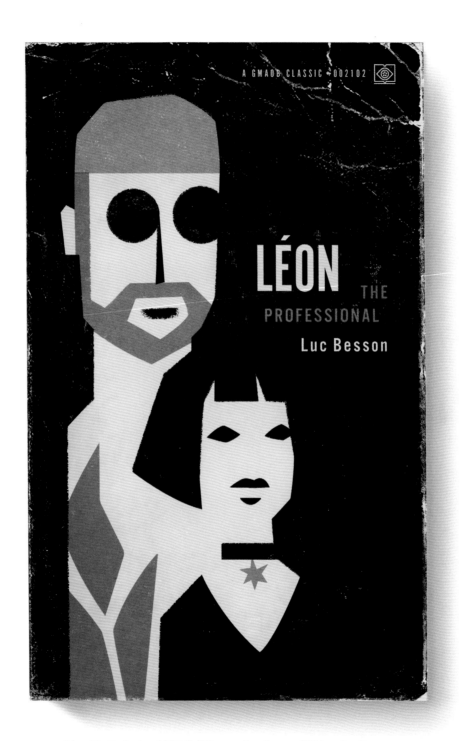

LÉON
THE
PROFESSIONAL

Luc Besson

Léon: The Professional (1994) / Director: Luc Besson / Writer: Luc Besson

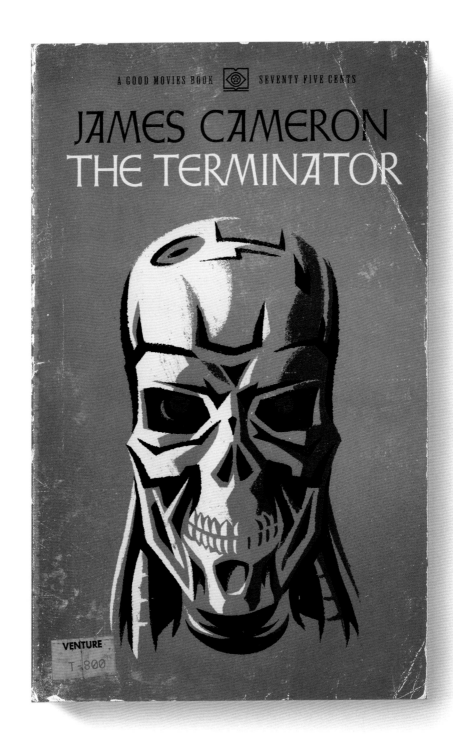

VENTURE
T-800

The Terminator (1984) / Director: James Cameron / Writers: James Cameron, Gale Anne Hurd, William Wisher

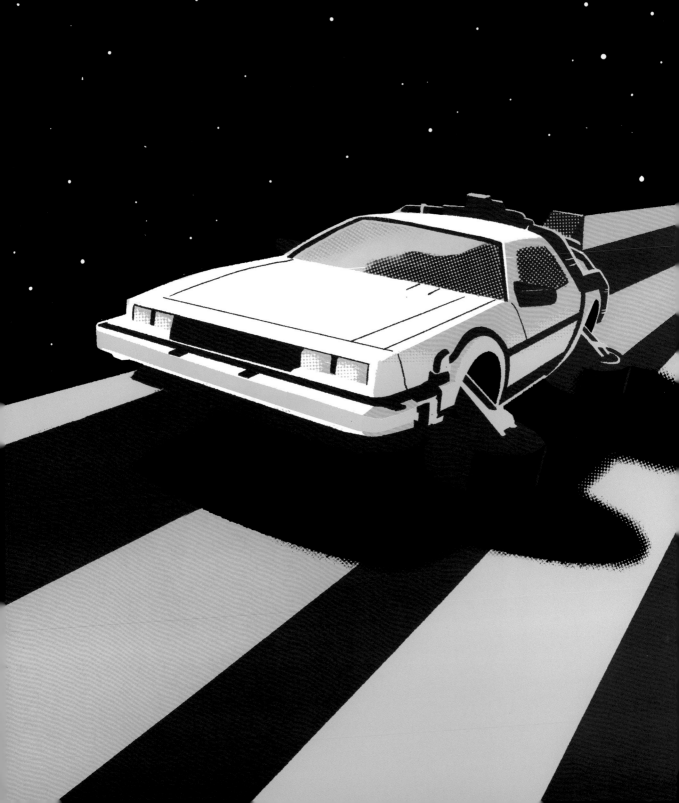

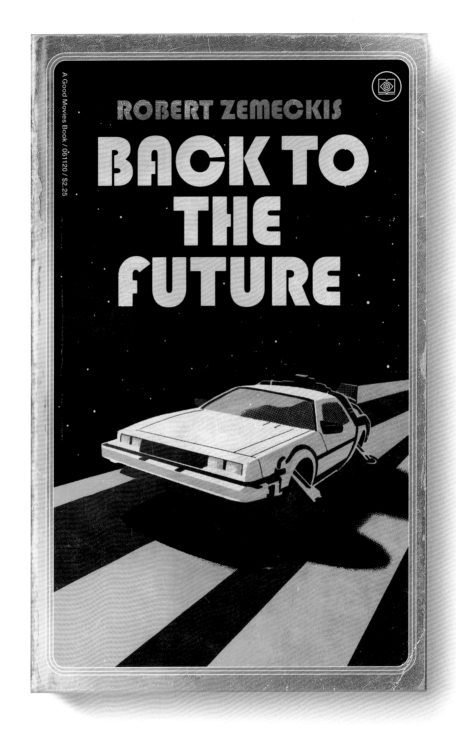

ROBERT ZEMECKIS

BACK TO THE FUTURE

A Good Movies Book / 061120 / $2.25

Back to the Future (1985) / Director: Robert Zemeckis / Writers: Robert Zemeckis, Bob Gale

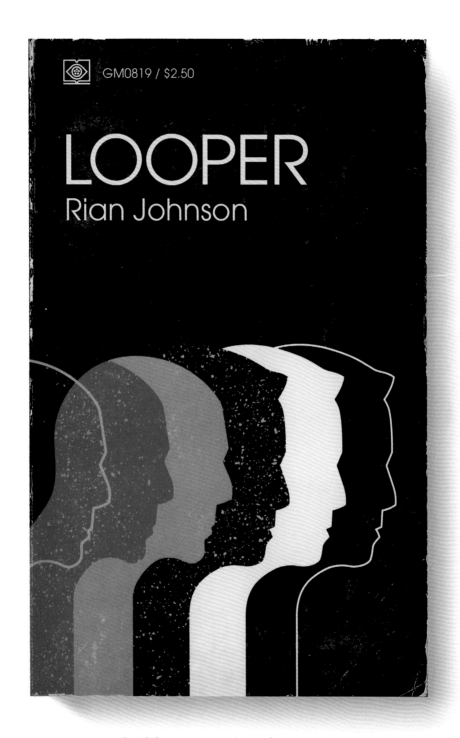

GM0819 / $2.50

LOOPER

Rian Johnson

Looper (2012) / Director: Rian Johnson / Writer: Rian Johnson

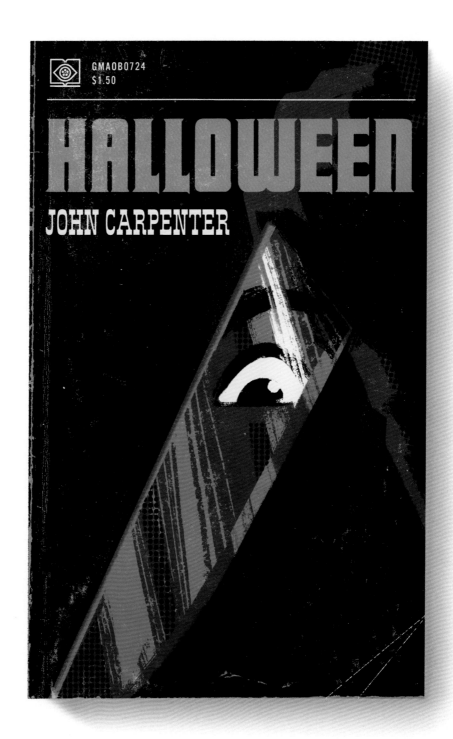

GMAOB0724
$1.50

HALLOWEEN

JOHN CARPENTER

Halloween (1978) / Director: John Carpenter / Writers: John Carpenter, Debra Hill

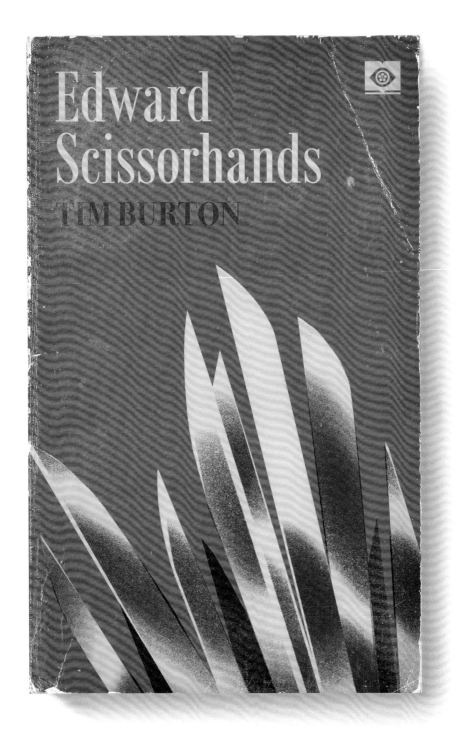

Edward Scissorhands (1990) / Director: Tim Burton / Writers: Tim Burton, Caroline Thompson

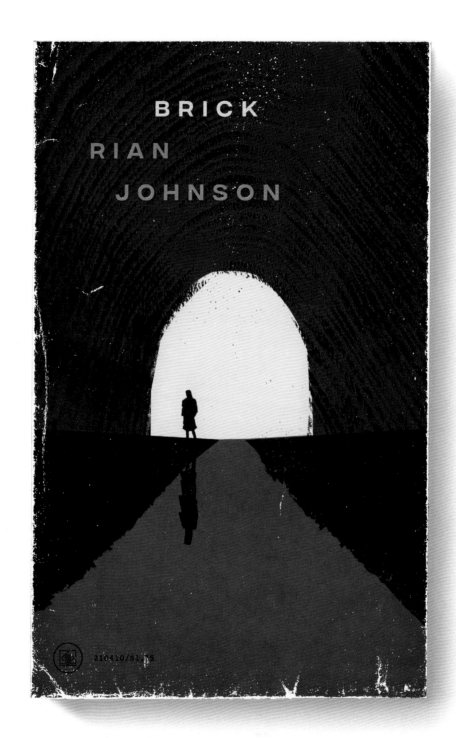

Brick (2005) / Director: Rian Johnson / Writer: Rian Johnson

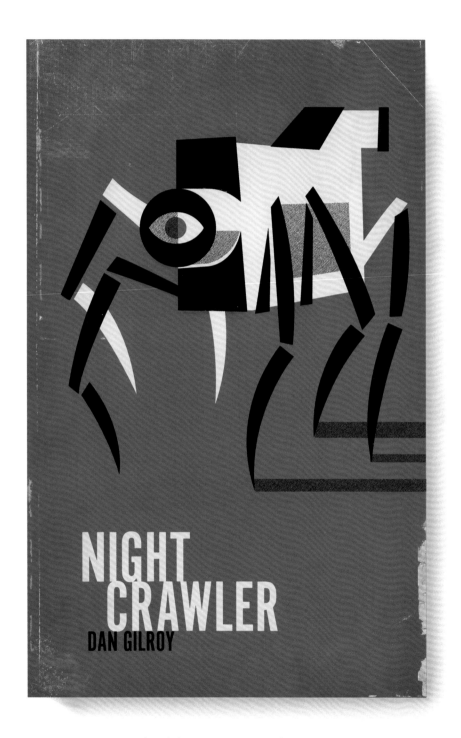

NIGHT
CRAWLER

DAN GILROY

Nightcrawler (2014) / Director: Dan Gilroy / Writer: Dan Gilroy

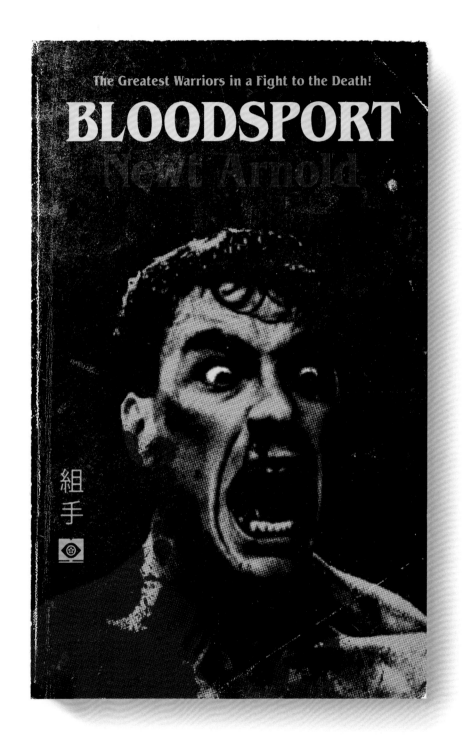

The Greatest Warriors in a Fight to the Death!

BLOODSPORT

Newt Arnold

組
手

Bloodsport (1988) / Director: Newt Arnold / Writers: Sheldon Lettich, Christopher Cosby, Mel Friedman

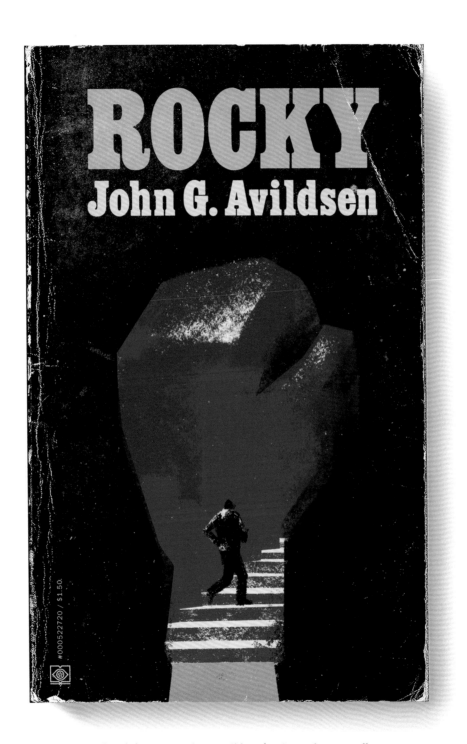

Rocky (1976) / Director: John G. Avildsen / Writer: Sylvester Stallone

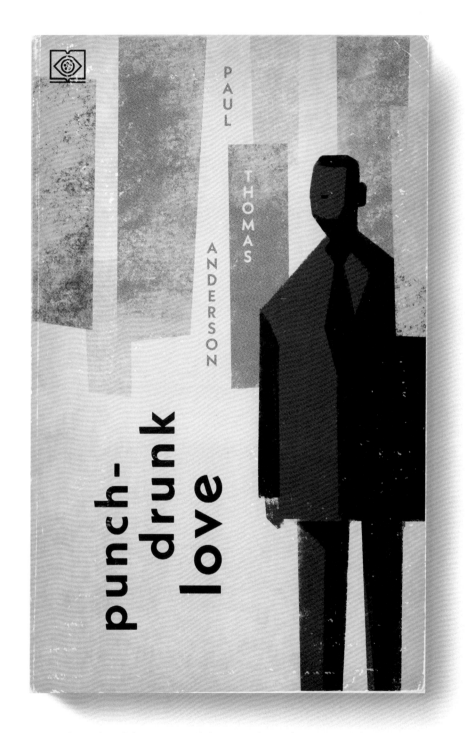

PAUL

THOMAS

ANDERSON

punch-
drunk
love

Punch-Drunk Love (2002) / Director: Paul Thomas Anderson / Writer: Paul Thomas Anderson

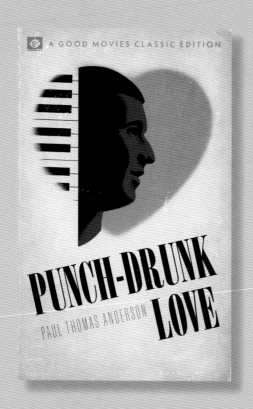

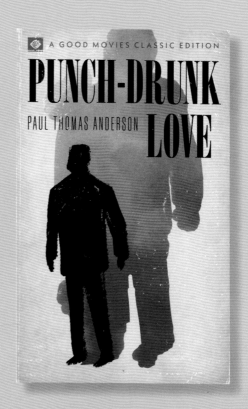

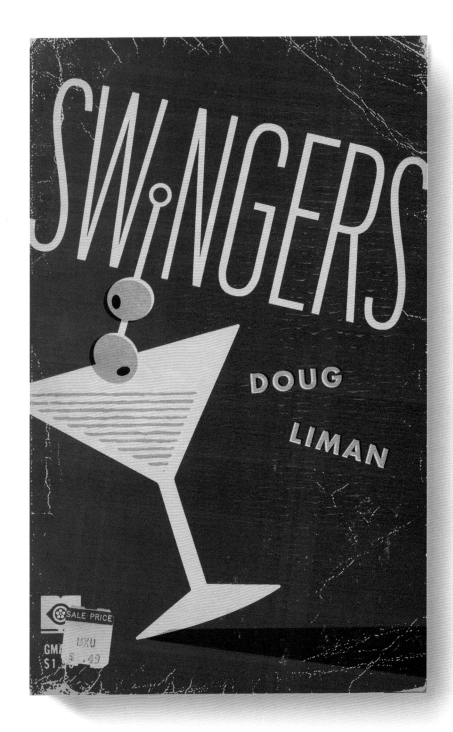

Swingers (1996) / Director: Doug Liman / Writer: Jon Favreau

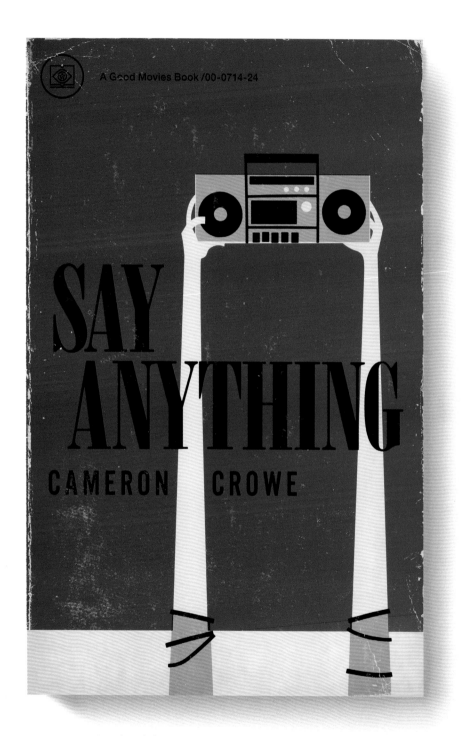

Say Anything (1989) / Director: Cameron Crowe / Writer: Cameron Crowe

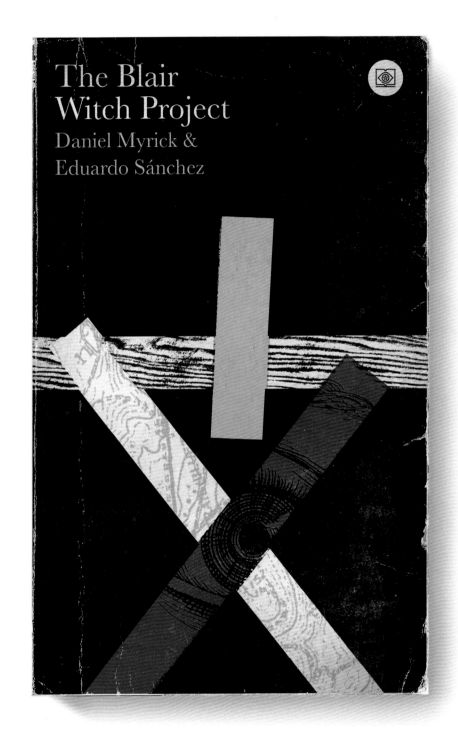

The Blair Witch Project (1999) / Directors: Daniel Myrick, Eduardo Sánchez
Writers: Daniel Myrick, Eduardo Sánchez, Heather Donahue

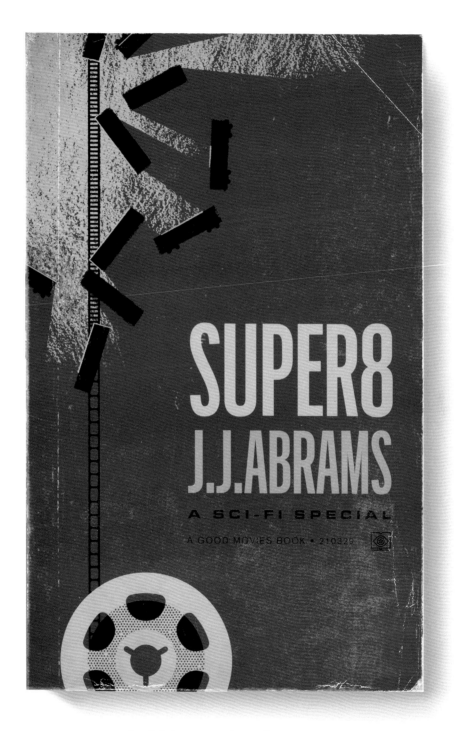

Super 8 (2011) / Director: J. J. Abrams / Writer: J. J. Abrams

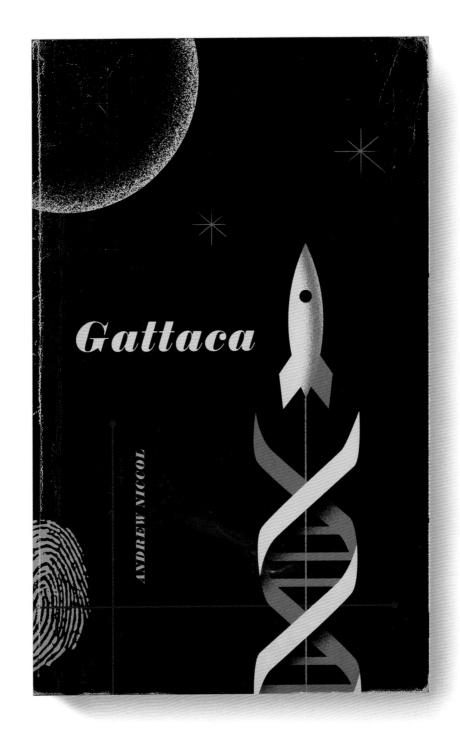

Gattaca (1997) / Director: Andrew Niccol / Writer: Andrew Niccol

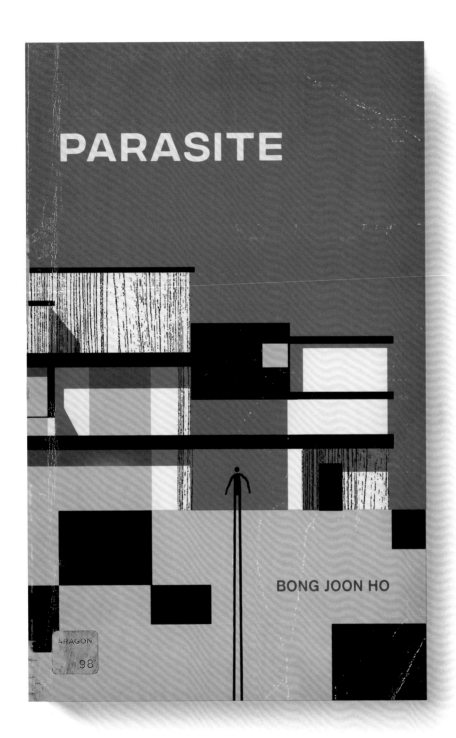

Parasite (2019) / Director: Bong Joon Ho / Writers: Bong Joon Ho, Han Jin-won

121

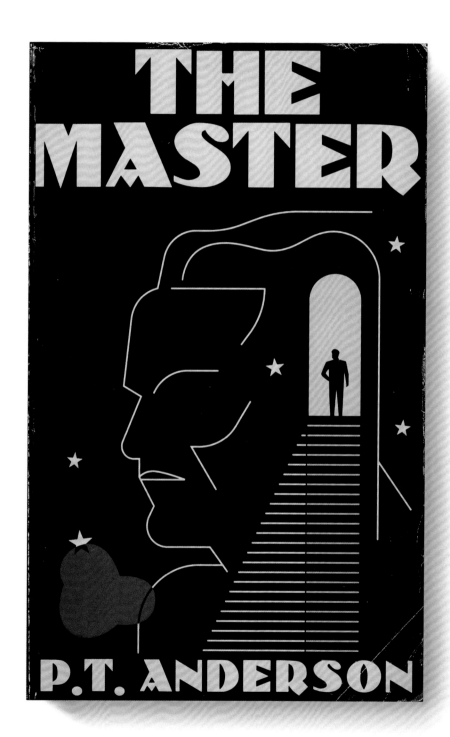

The Master (2012) / Director: Paul Thomas Anderson / Writer: Paul Thomas Anderson

The Master

PAUL THOMAS ANDERSON

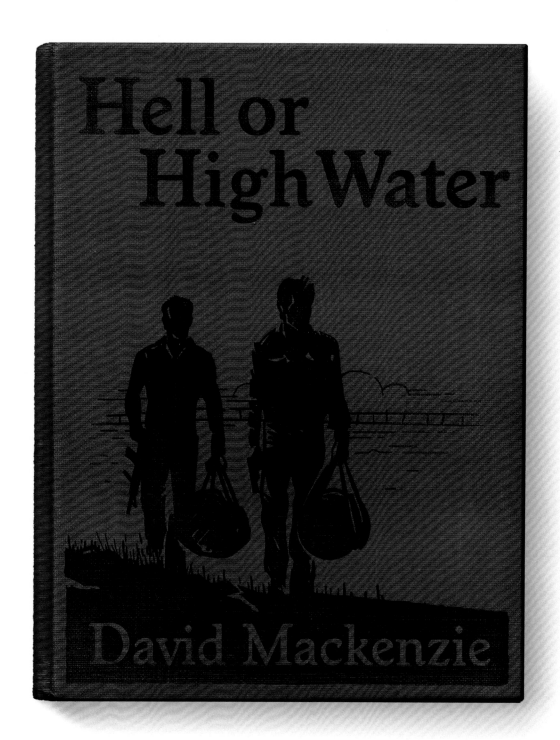

Hell or High Water (2016) / Director: David Mackenzie / Writer: Taylor Sheridan

DAVID MACKENZIE

HELL OR HIGH WATER

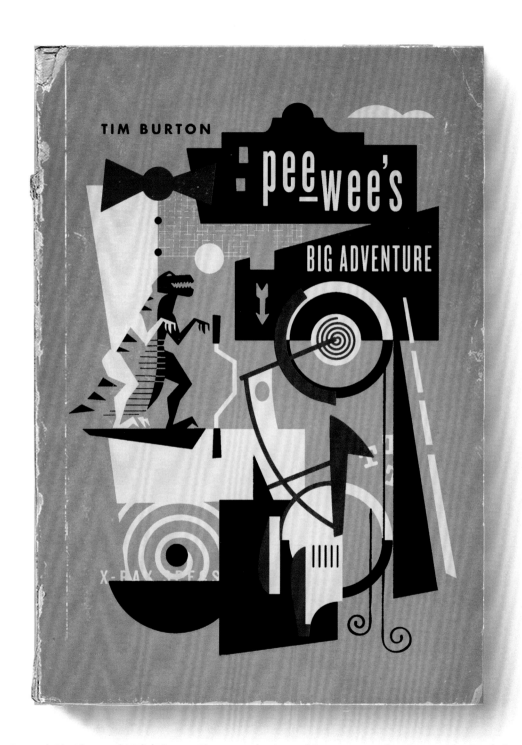

Pee-wee's Big Adventure (1985) / Director: Tim Burton / Writers: Phil Hartman, Paul Reubens, Michael Varhol

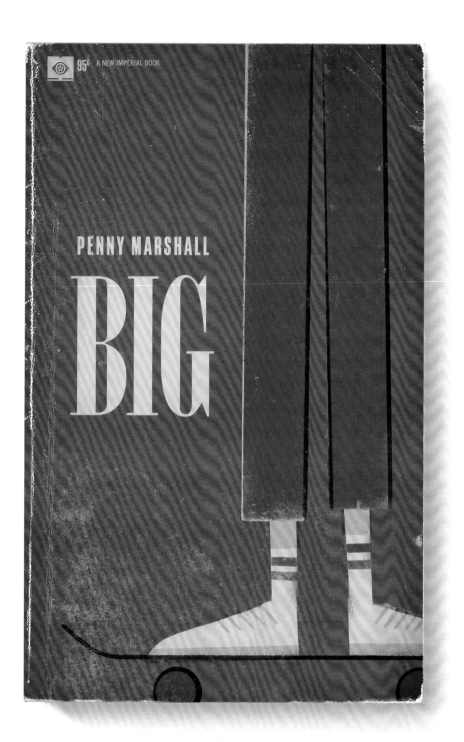

PENNY MARSHALL

BIG

Big (1988) / Director: Penny Marshall / Writers: Gary Ross, Anne Spielberg

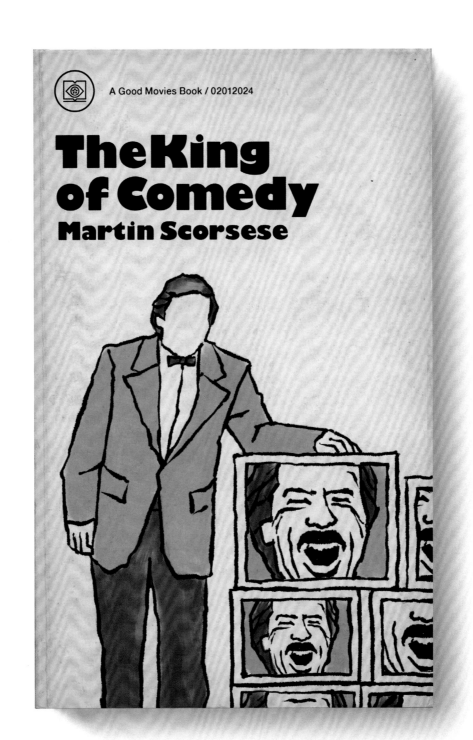

The King of Comedy (1982) / Director: Martin Scorsese / Writer: Paul D. Zimmerman

The King of Comedy

MARTIN SCORSESE

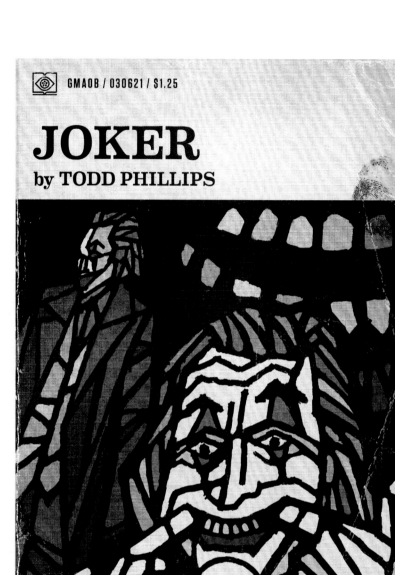

JOKER
by TODD PHILLIPS

Joker (2019) / Director: Todd Phillips / Writers: Todd Phillips, Scott Silver, Bob Cane, Bill Finger, Jerry Robinson

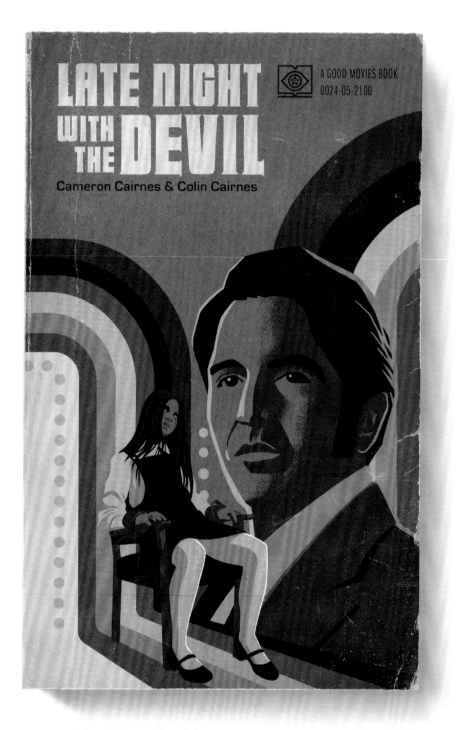

Late Night with the Devil (2023) / Directors: Cameron Cairnes, Colin Cairnes
Writers: Cameron Cairnes, Colin Cairnes

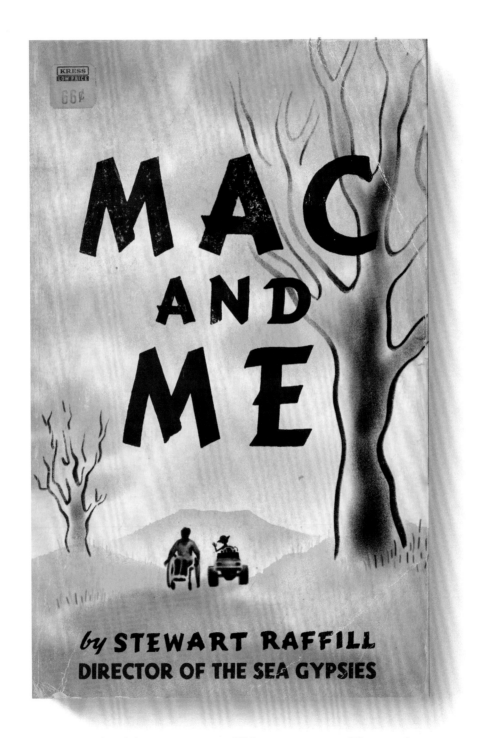

Mac and Me (1988) / Director: Stewart Raffill / Writers: Stewart Raffill, Steve Feke

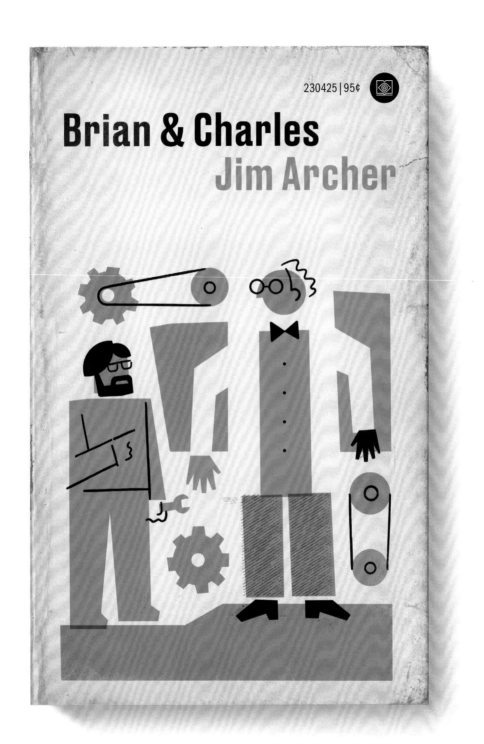

Brian & Charles
Jim Archer

Brian and Charles (2022) / Director: Jim Archer / Writers: David Earl, Chris Hayward

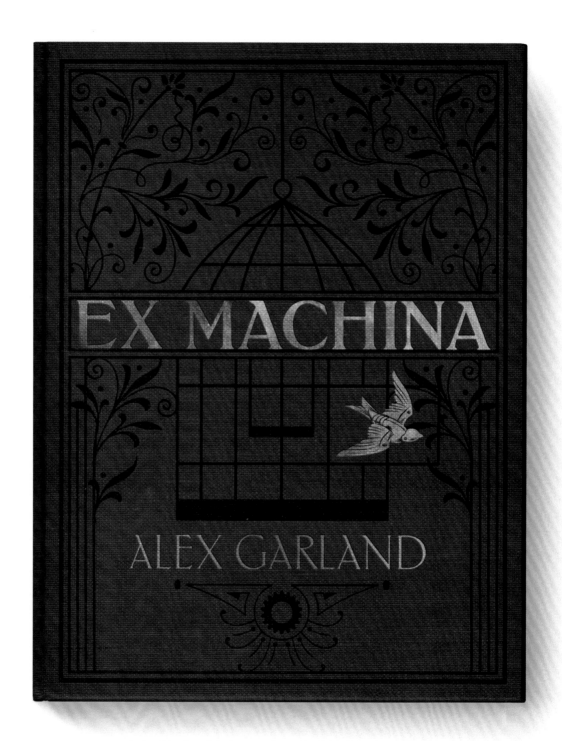

Ex Machina (2014) / Director: Alex Garland / Writer: Alex Garland

MMXIV

EX
MACHINA

ALEX GARLAND

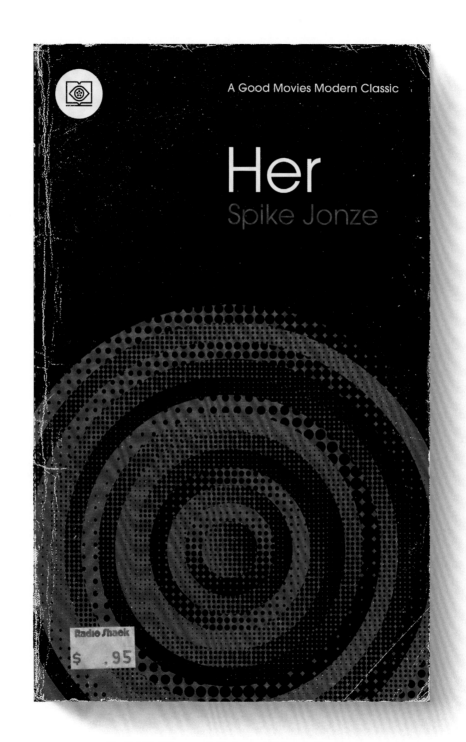

A Good Movies Modern Classic

Her
Spike Jonze

Radio Shack
$.95

Her (2013) / Director: Spike Jonze / Writer: Spike Jonze

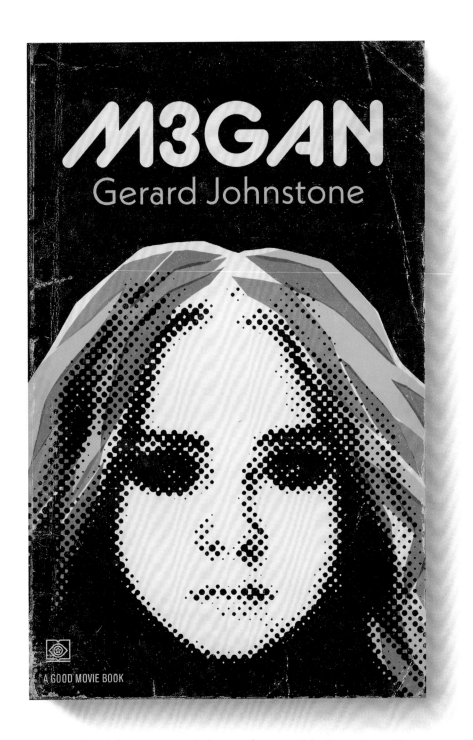

M3GAN (2022) / Director: Gerard Johnstone / Writers: Aleka Cooper, James Wan

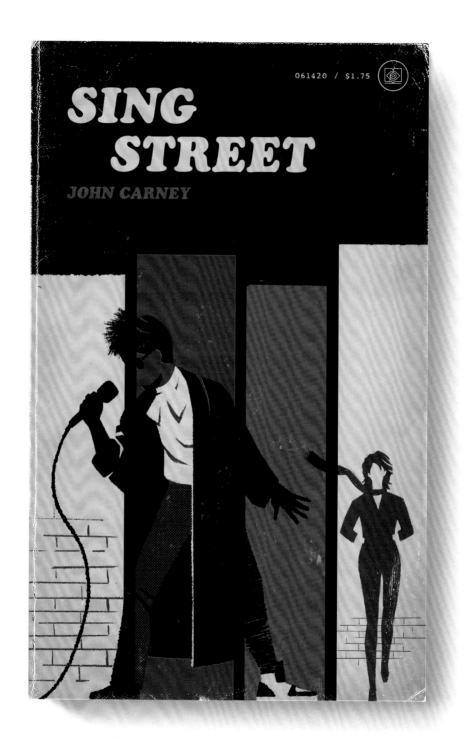

Sing Street (2016) / Director: John Carney / Writers: Simon Carmody, John Carney

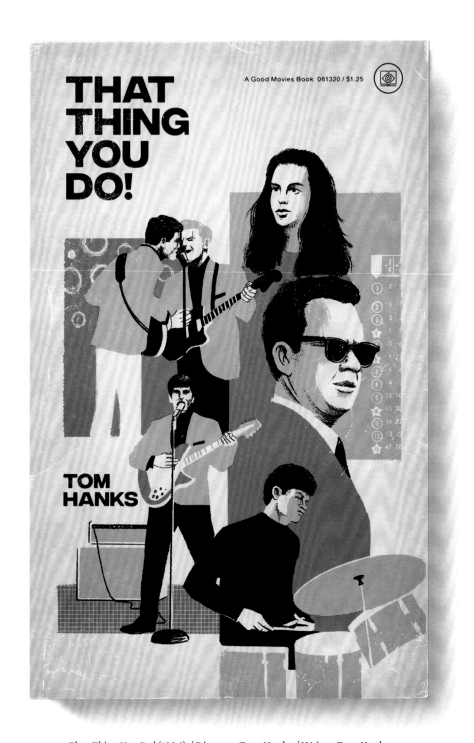

THAT
THING
YOU
DO!

A Good Movies Book 061320 / $1.25

TOM
HANKS

That Thing You Do! (1996) / Director: Tom Hanks / Writer: Tom Hanks

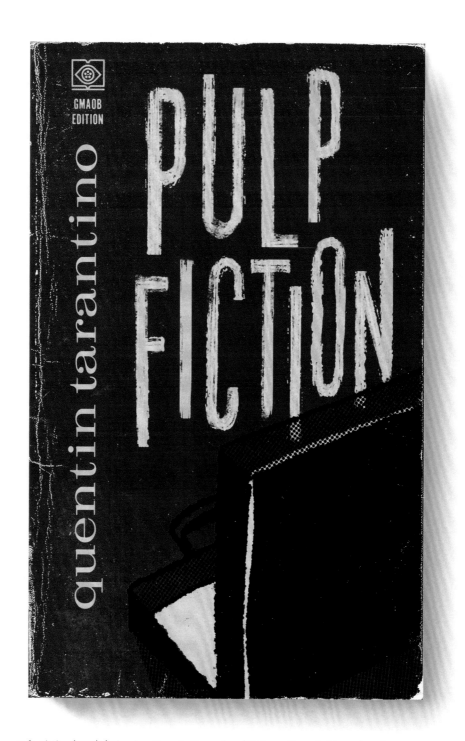

140 *Pulp Fiction* (1994) / Director: Quentin Tarantino / Writers: Quentin Tarantino, Roger Avary

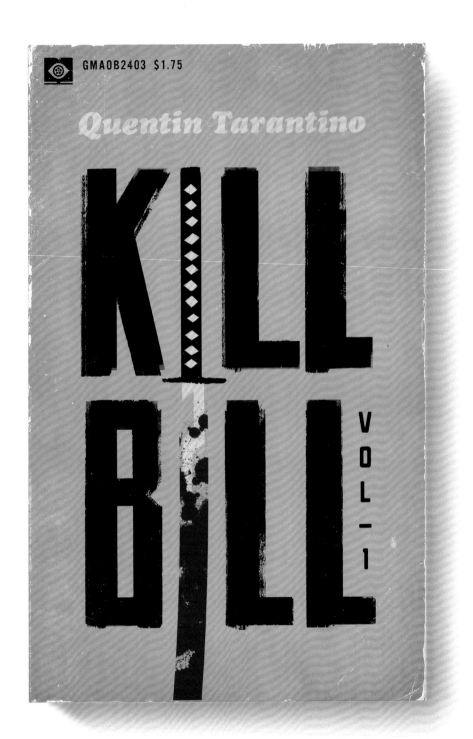

Kill Bill: Volume 1 (2003) / Director: Quentin Tarantino / Writers: Quentin Tarantino, Uma Thurman

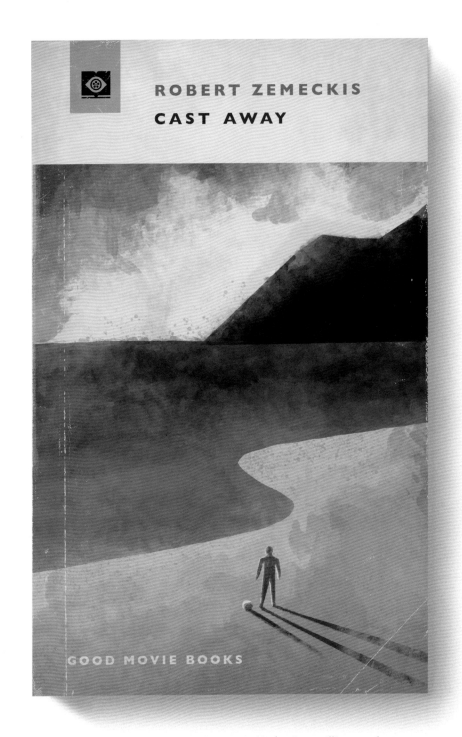

ROBERT ZEMECKIS

CAST AWAY

GOOD MOVIE BOOKS

Cast Away (2000) / Director: Robert Zemeckis / Writer: William Broyles Jr.

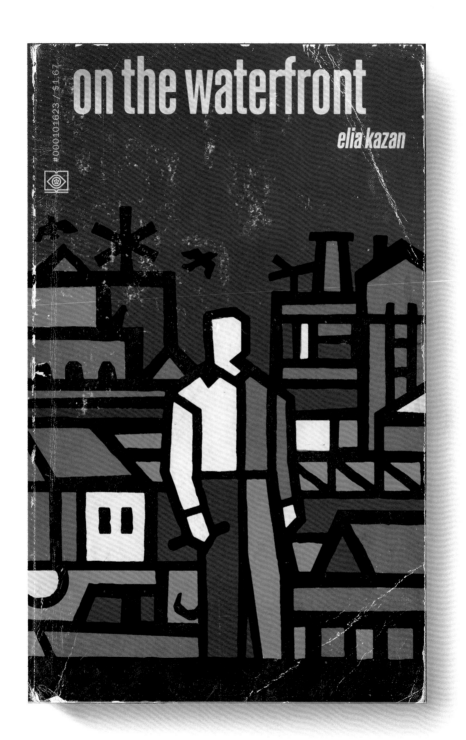

On the Waterfront (1954) / Director: Elia Kazan
Writers: Budd Schulberg, Malcom Johnson, Robert Siodmak (uncredited)

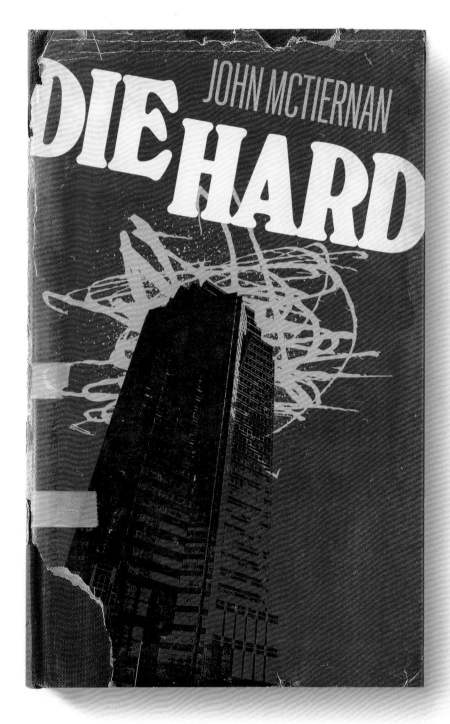

Die Hard (1988) / Director: John McTiernan / Writers: Jeb Stuart, Steven E. de Souza
Original Novel: Roderick Thorp

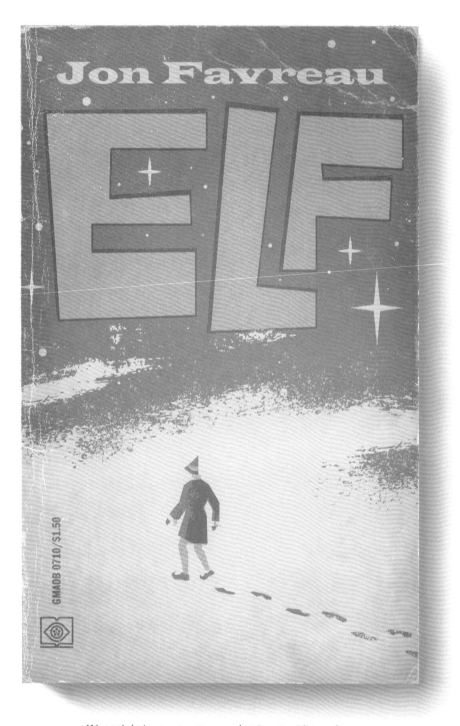

Elf (2003) / Director: Jon Favreau / Writer: David Berenbaum

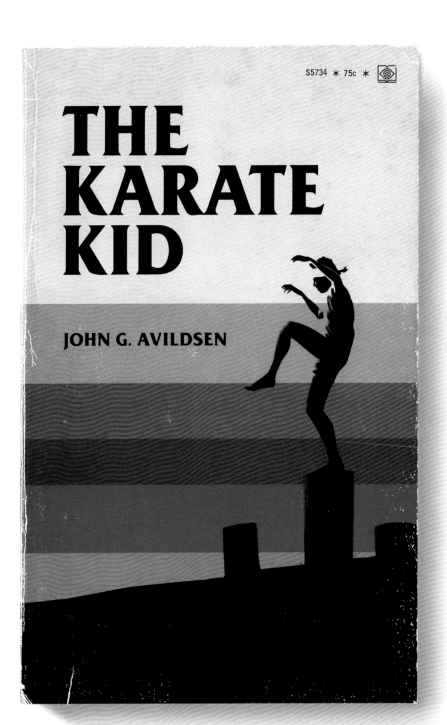

THE KARATE KID

JOHN G. AVILDSEN

The Karate Kid (1984) / Director: John G. Avildsen / Writer: Robert Mark Kamen

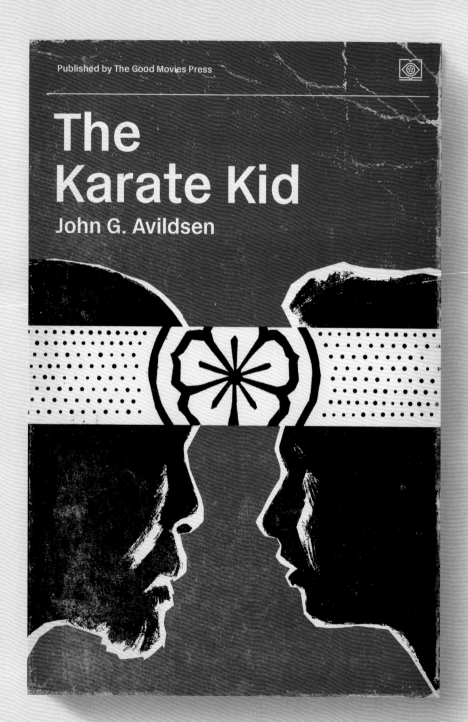

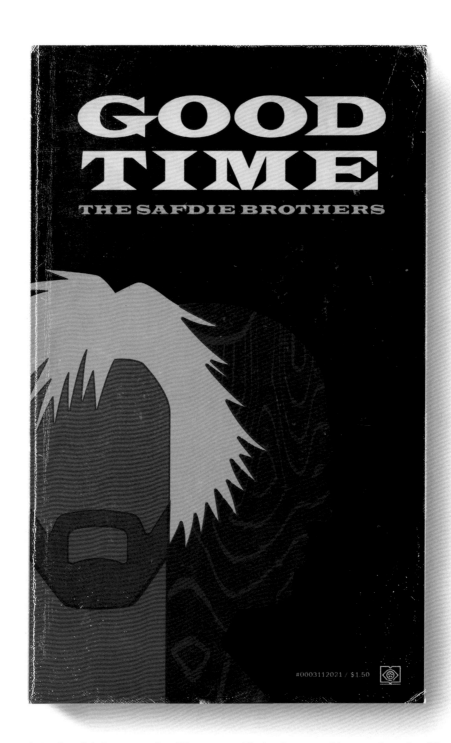

Good Time (2017) / Directors: Josh Safdie, Benny Safdie / Writers: Ronald Bronstein, Josh Safdie

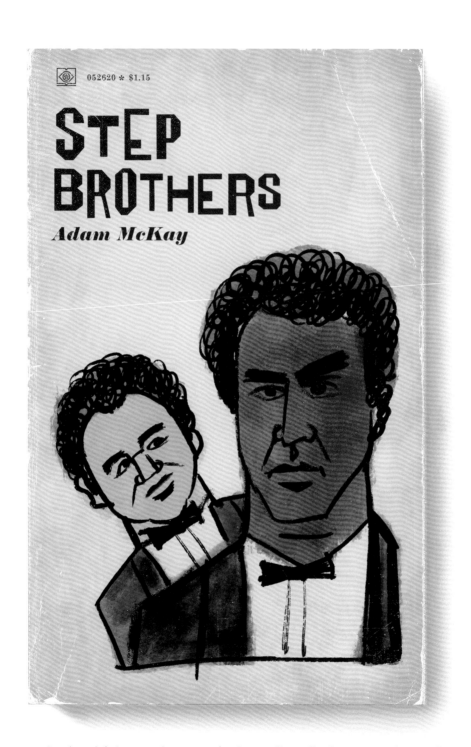

Step Brothers (2008) / Director: Adam McKay / Writers: Will Ferrell, Adam McKay, John C. Reilly

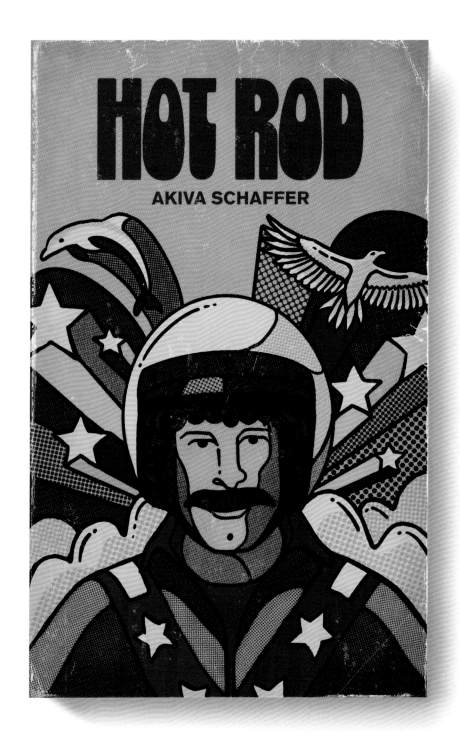

Hot Rod (2007) / Director: Akiva Schaffer
Writers: Akiva Schaffer, Pam Brady, Andy Samberg, Jorma Taccone

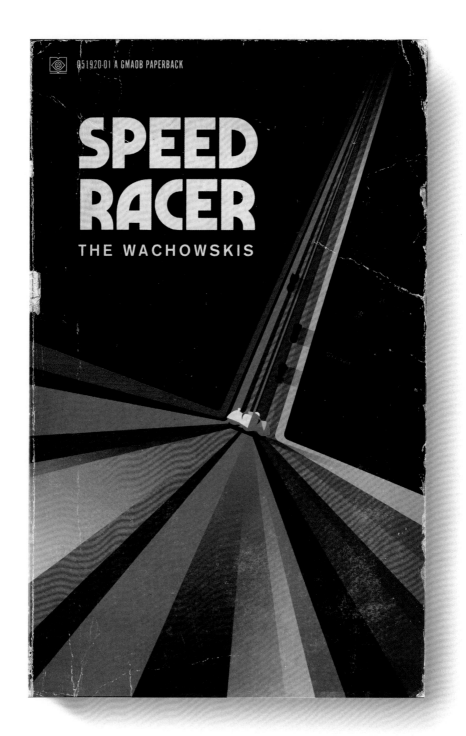

SPEED RACER

THE WACHOWSKIS

Speed Racer (2008) / Directors: Lilly Wachowski, Lana Wachowski
Writers: Lilly Wachowski, Lana Wachowski / Original Animated Series: Tatsuo Yoshida

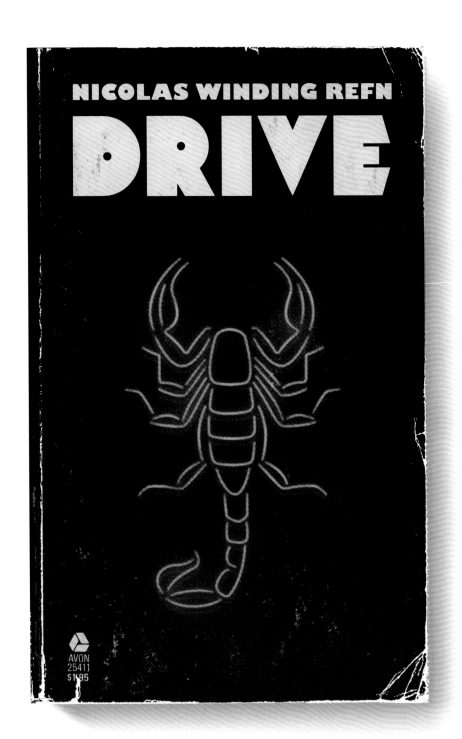

Drive (2011) / Director: Nicolas Winding Refn / Writers: Hossein Amini, James Sallis

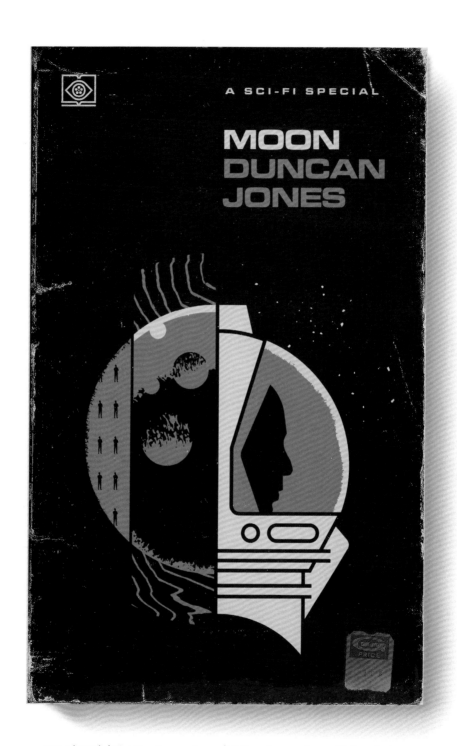

A SCI-FI SPECIAL

MOON
DUNCAN JONES

Moon (2009) / Director: Duncan Jones / Writers: Duncan Jones, Nathan Parker

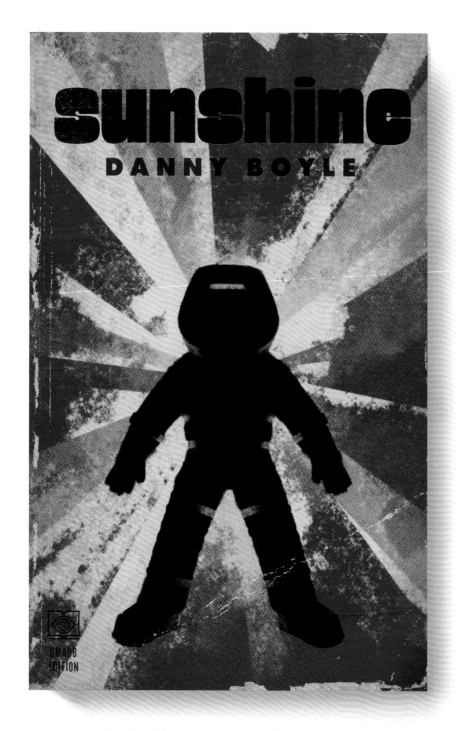

Sunshine (2007) / Director: Danny Boyle / Writer: Alex Garland

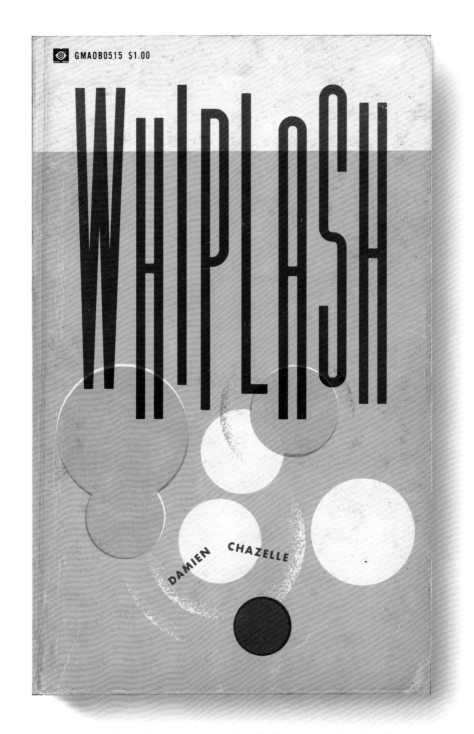

WHIPLASH

DAMIEN CHAZELLE

Whiplash (2014) / Director: Damien Chazelle / Writer: Damien Chazelle

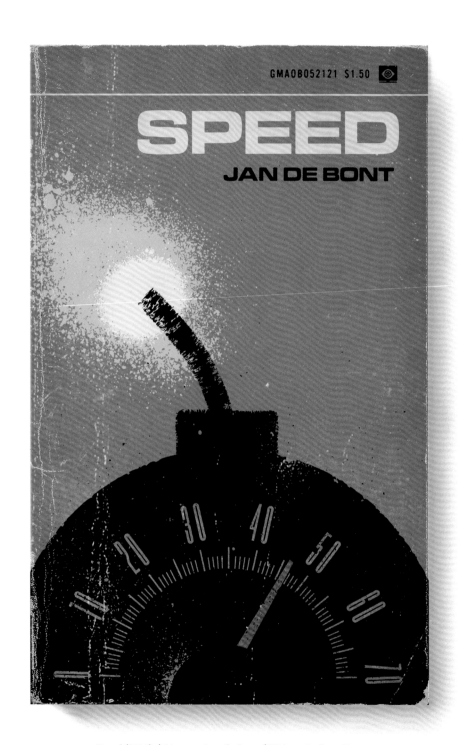

Speed (1994) / Director: Jan de Bont / Writer: Graham Yost

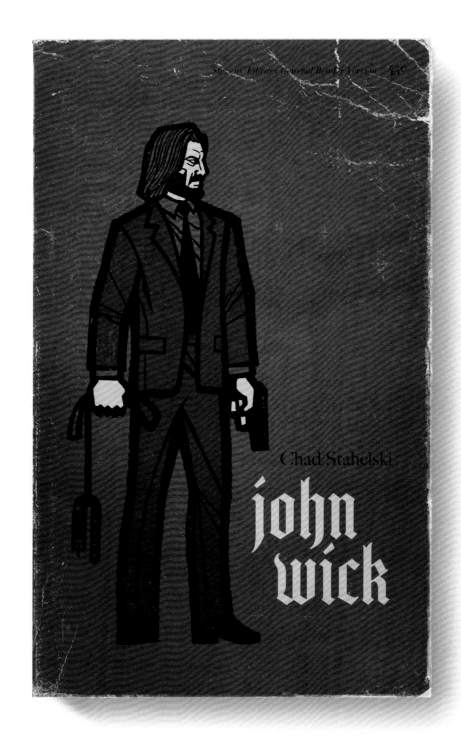

Chad Stahelski

john wick

John Wick (2014) / Director: Chad Stahelski / Writer: Derek Kolstad

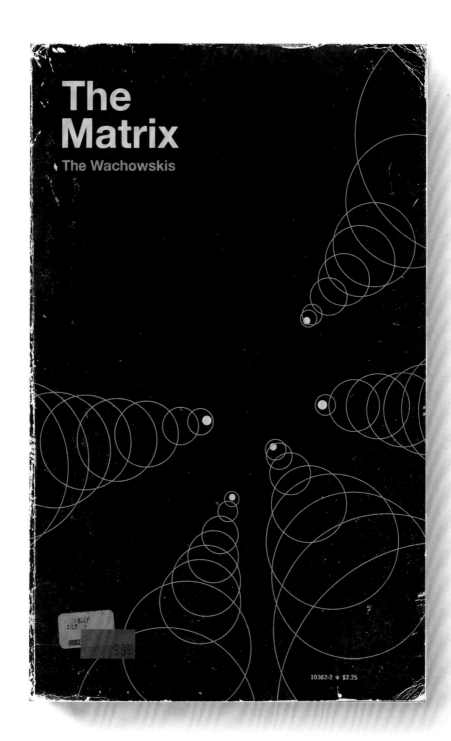

The Matrix
The Wachowskis

10382-2 ✳ $2.25

The Matrix (1999) / Directors: Lilly Wachowski, Lana Wachowski / Writers: Lilly Wachowski, Lana Wachowski

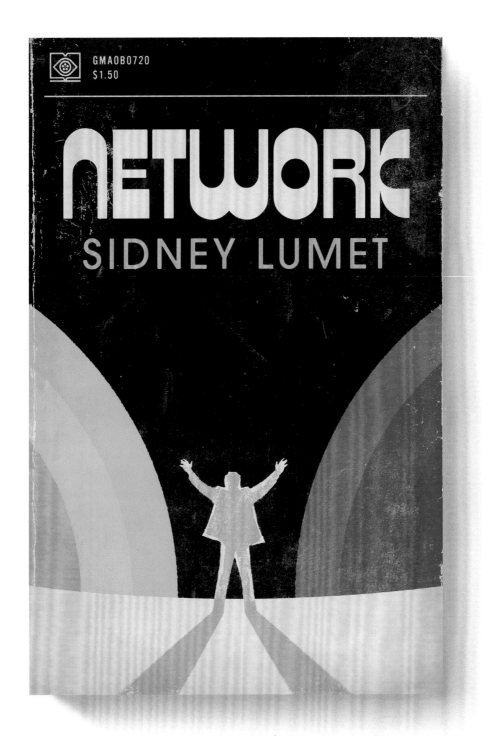

GMAOB0720
$1.50

NETWORK
SIDNEY LUMET

Network (1976) / Director: Sidney Lumet / Writer: Paddy Chayefsky

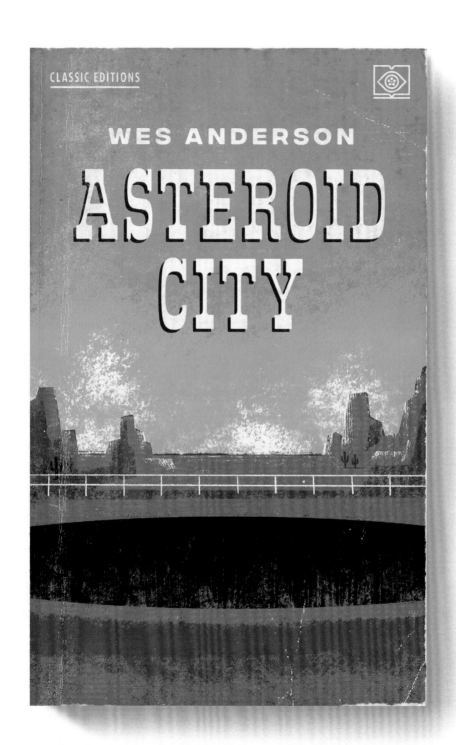

Asteroid City (2023) / Director: Wes Anderson / Writers: Wes Anderson, Roman Coppola

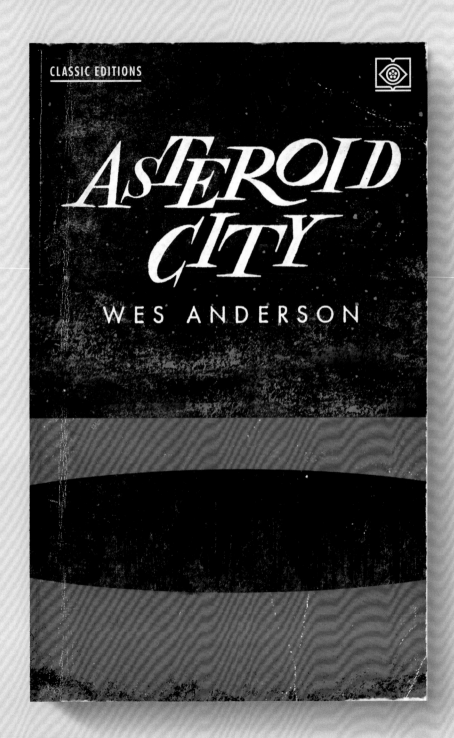

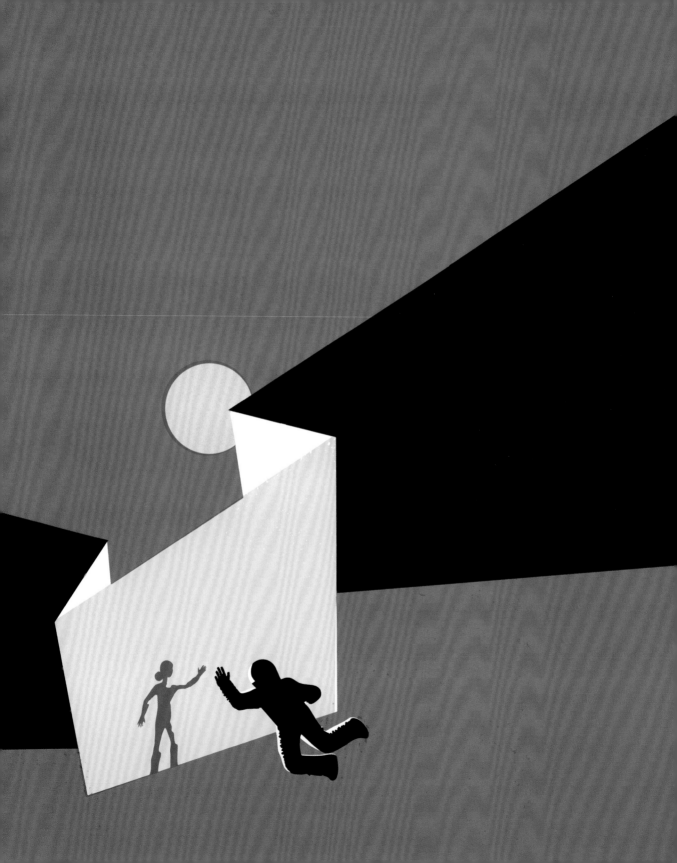

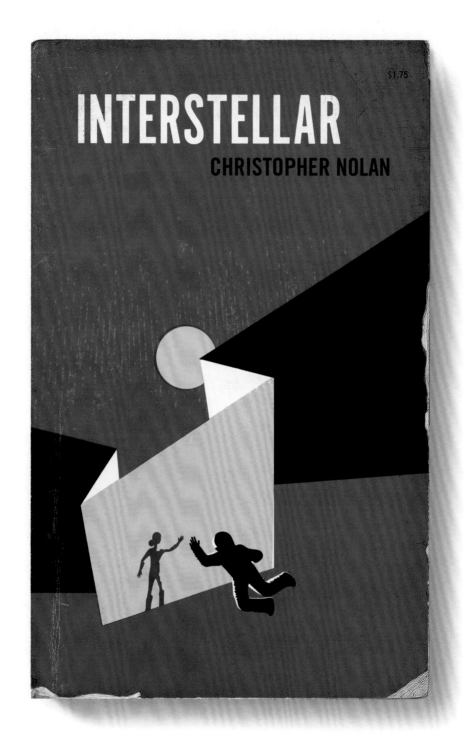

Interstellar (2014) / Director: Christopher Nolan / Writers: Jonathan Nolan, Christopher Nolan

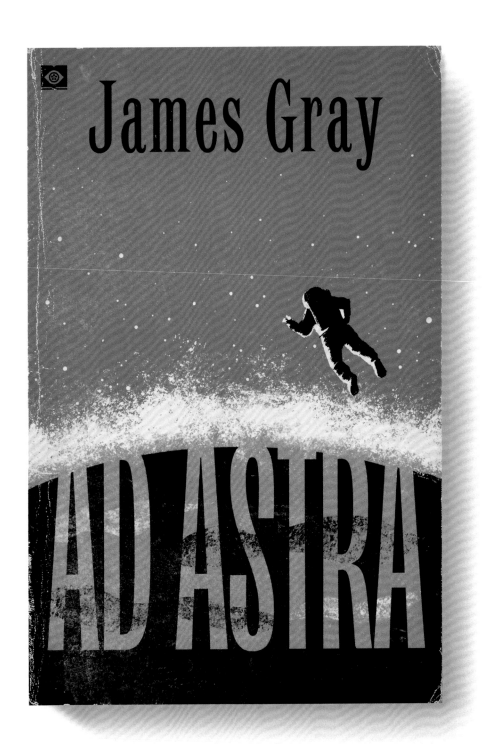

Ad Astra (2019) / Director: James Gray / Writers: James Gray, Ethan Gross

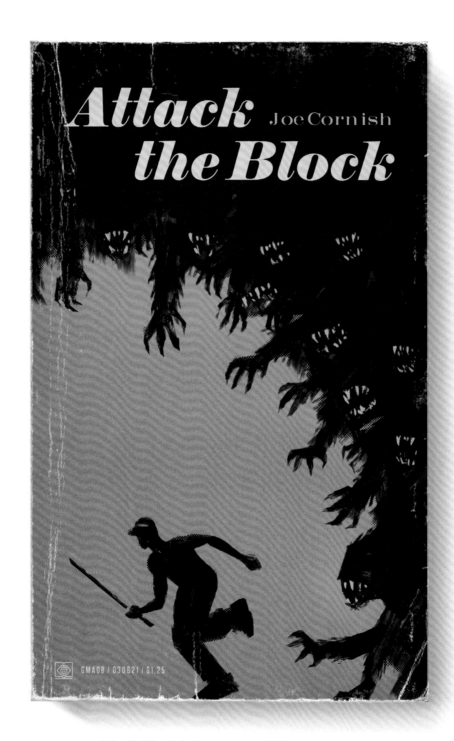

Attack the Block (2011) / Director: Joe Cornish / Writer: Joe Cornish

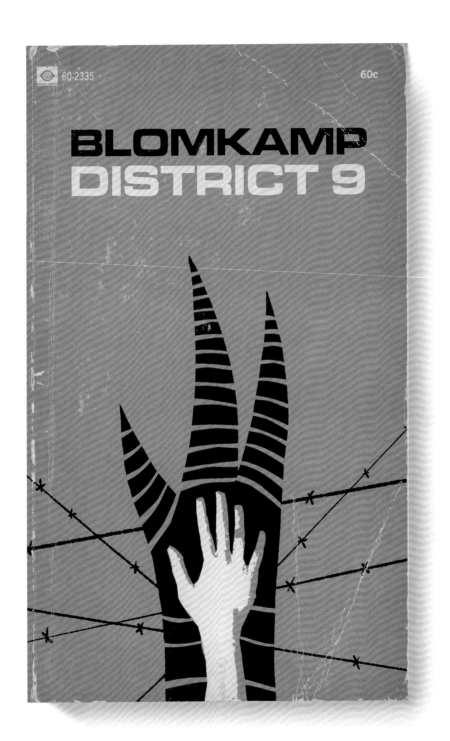

District 9 (2009) / Director: Neill Blomkamp / Writers: Neill Blomkamp, Terri Tatchell

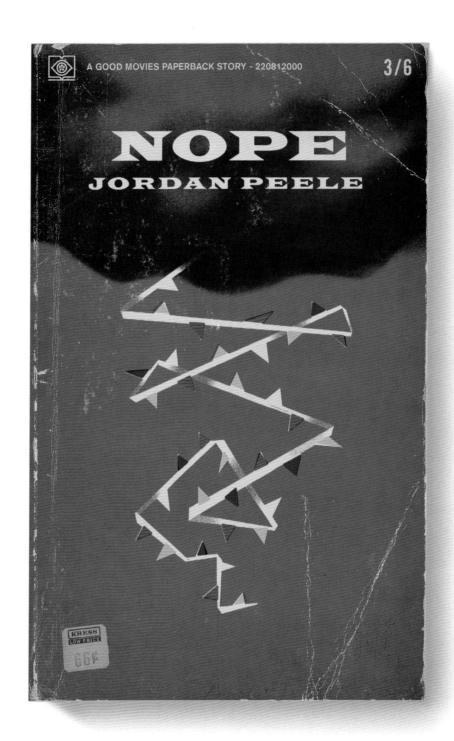

NOPE

JORDAN PEELE

Nope (2022) / Director: Jordan Peele / Writer: Jordan Peele

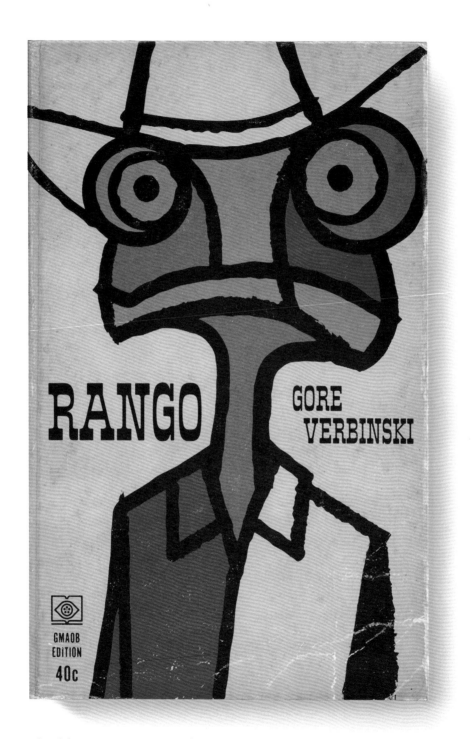

RANGO

GORE VERBINSKI

GMAOB
EDiTiON
40c

Rango (2011) / Director: Gore Verbinski / Writers: John Logan, Gore Verbinski, James Ward Byrkit

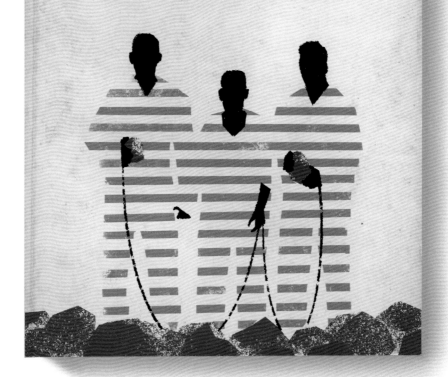

85¢
In Canada $1.00

THE COEN BROTHERS

O Brother, Where Art Thou?

O Brother, Where Art Thou? (2000) / Directors: Joel Coen, Ethan Coen
Writers: Ethan Coen, Joel Coen / Original Poem: Homer

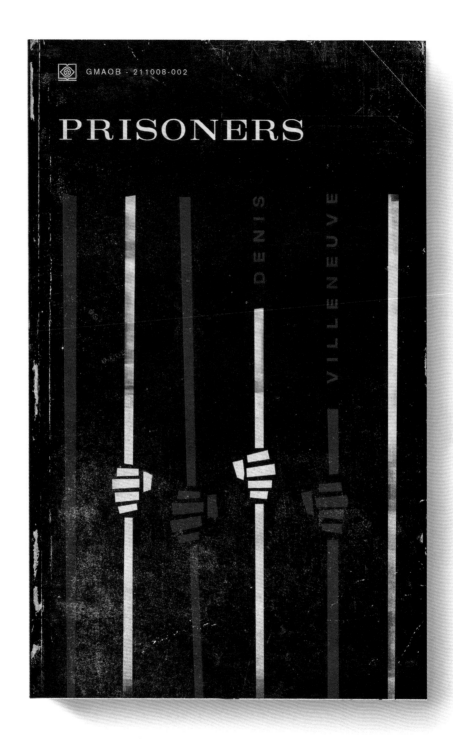

Prisoners (2013) / Director: Denis Villeneuve / Writer: Aaron Guzikowski

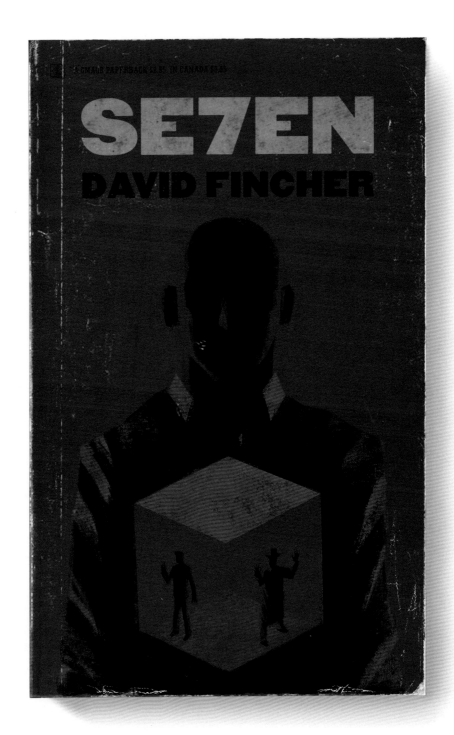

Seven (1995) / Director: David Fincher / Writer: Andrew Kevin Walker

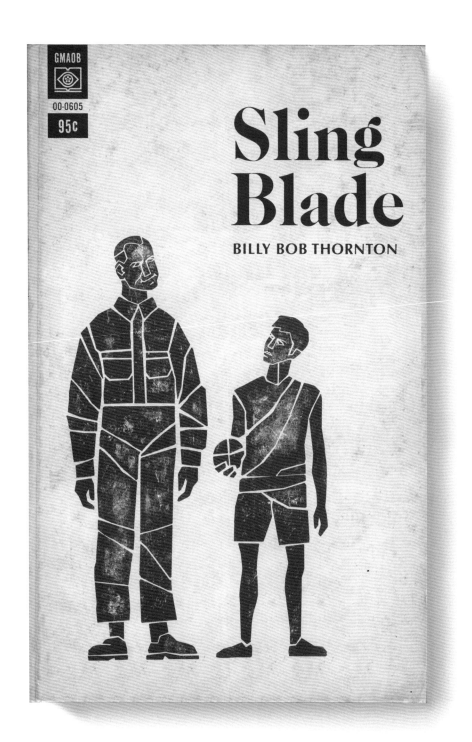

GMAOB

00-0605

95c

Sling Blade

BILLY BOB THORNTON

Sling Blade (1996) / Director: Billy Bob Thornton / Writer: Billy Bob Thornton

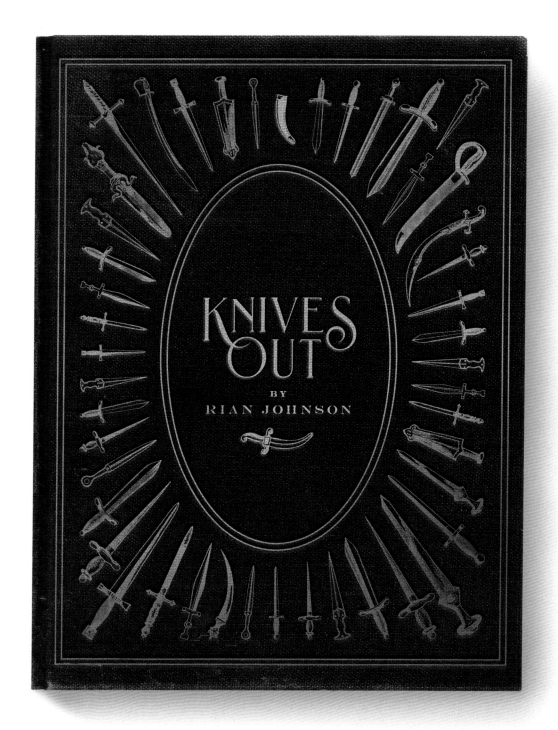

Knives Out (2019) / Director: Rian Johnson / Writer: Rian Johnson

Knives
Out

A MYSTERY BY

RIAN JOHNSON

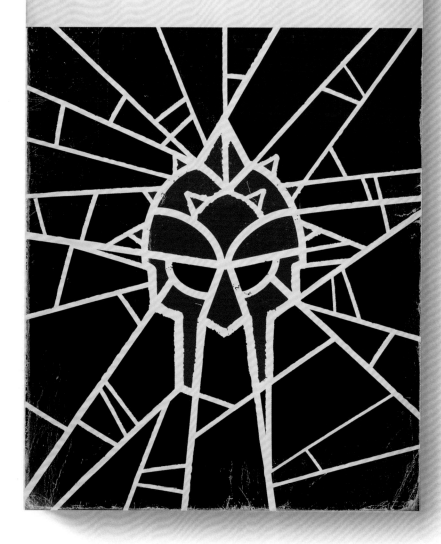

Gladiator (2000) / Director: Ridley Scott / Writers: David Franzoni, John Logan, William Nicholson

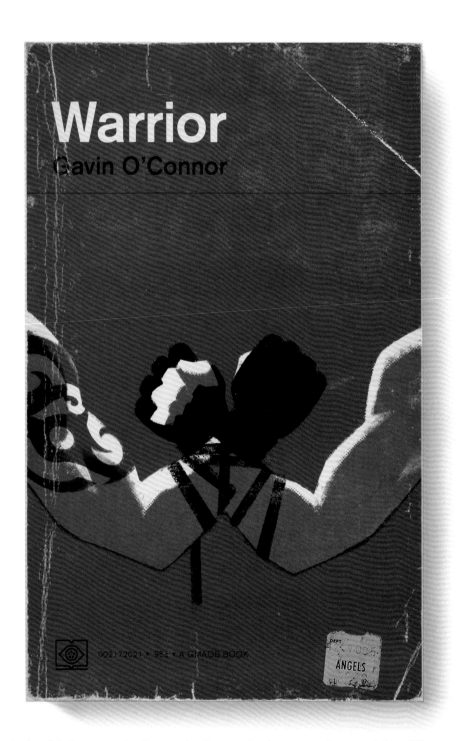

Warrior

Gavin O'Connor

002172021 • 95¢ • A GMADB BOOK

DEPT
ANGELS

Warrior (2011) / Director: Gavin O'Connor / Writers: Gavin O'Connor, Anthony Tambakis, Cliff Dorman 185

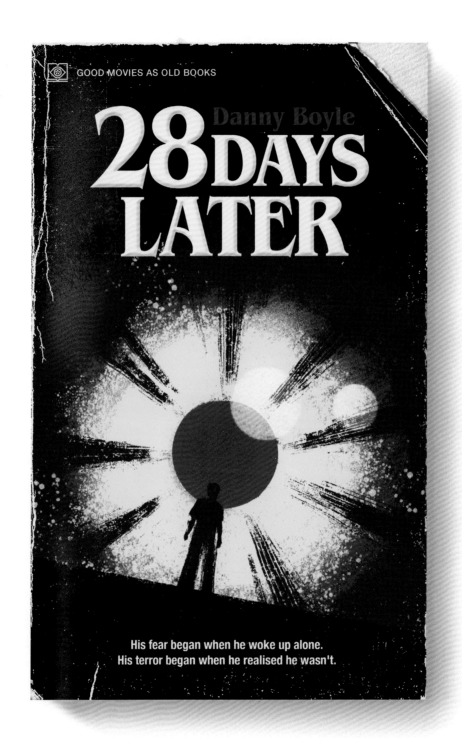

28 Days Later (2002) / Director: Danny Boyle / Writer: Alex Garland

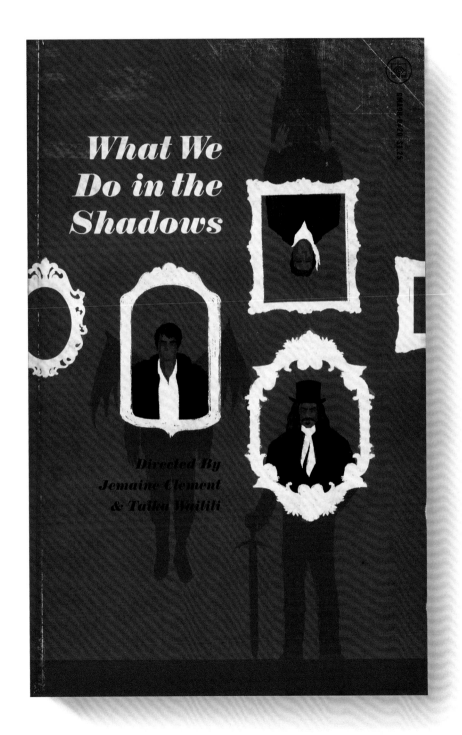

What We Do in the Shadows (2014) / Directors: Jemaine Clement, Taika Waititi
Writers: Jemaine Clement, Taika Waititi

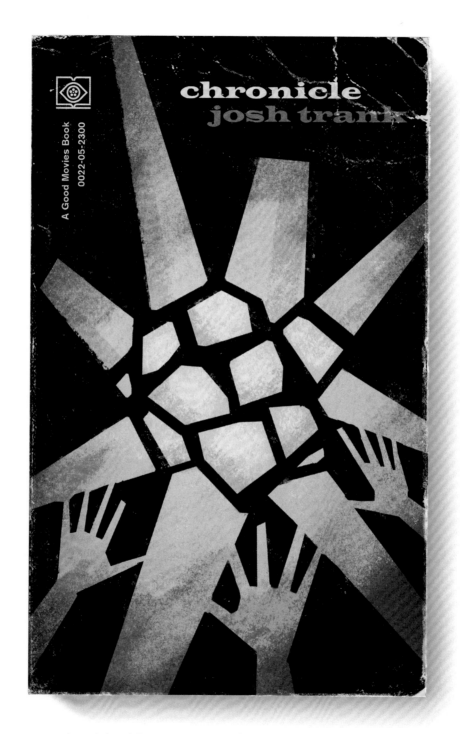

chronicle
josh trank

A Good Movies Book
0022-05-2300

Chronicle (2012) / Director: Josh Trank / Writers: Max Landis, Josh Trank

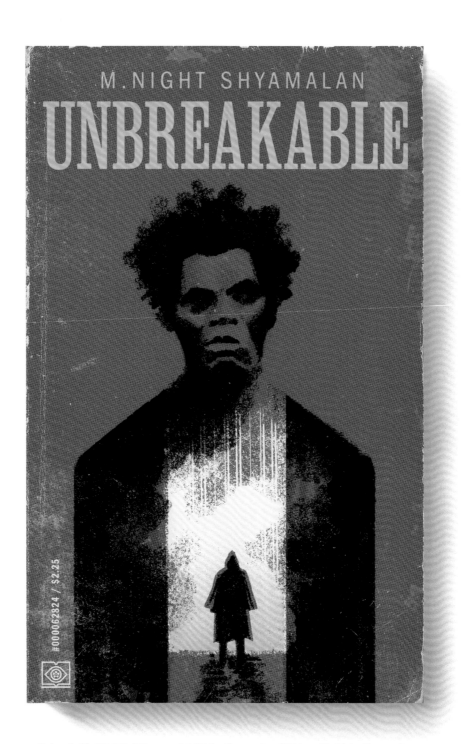

Unbreakable (2000) / Director: M. Night Shyamalan / Writer: M. Night Shyamalan

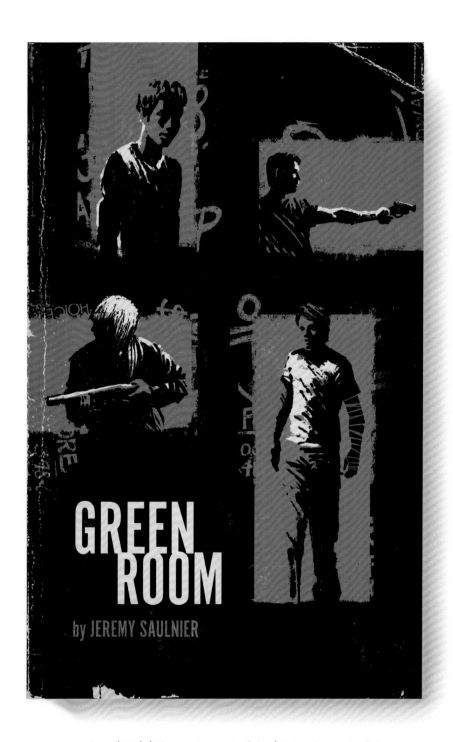

Green Room (2015) / Director: Jeremy Saulnier / Writer: Jeremy Saulnier

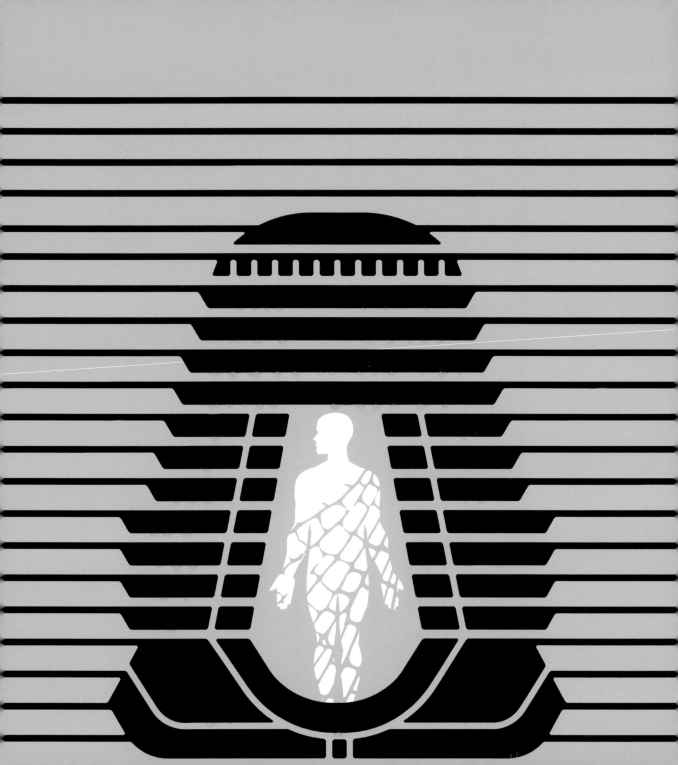

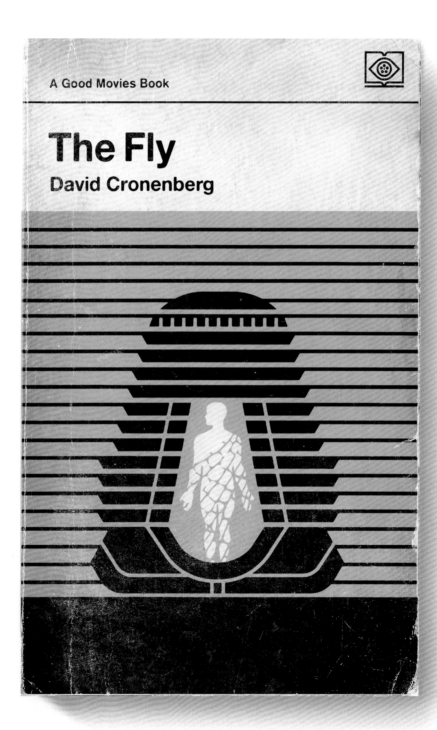

The Fly (1986) / Director: David Cronenberg / Writers: Charles Edward Pogue, David Cronenberg
Original Short Story: George Langelaan

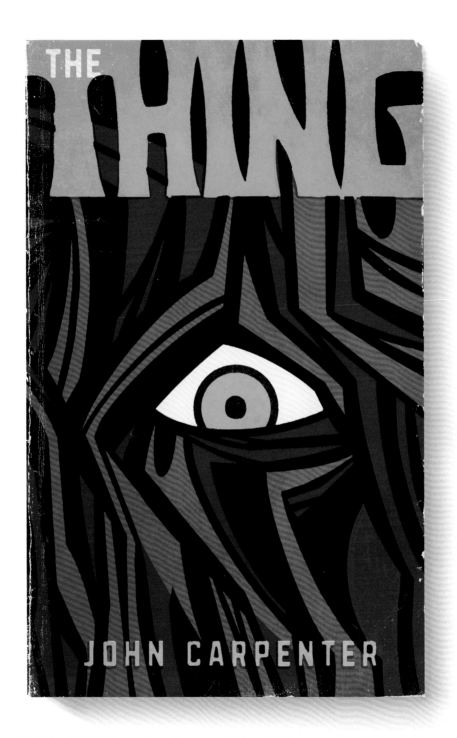

The Thing (1982) / Director: John Carpenter / Writers: Bill Lancaster, John W. Campbell Jr.

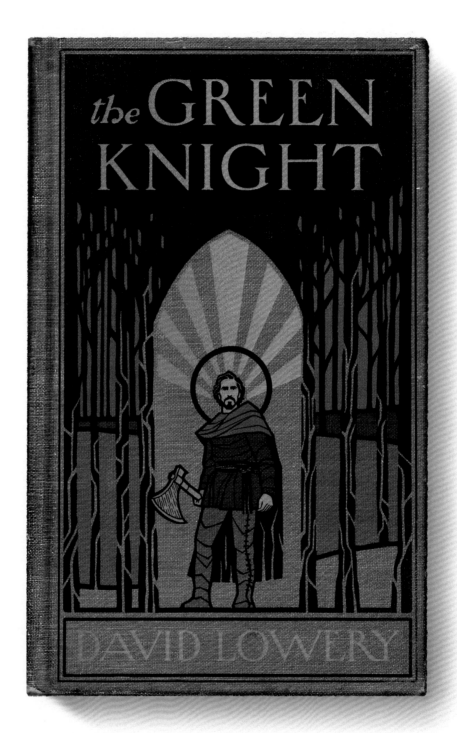

The Green Knight (2021) / Director: David Lowery / Writer: David Lowery
Original Work: The Gawain Poet

THE
GREEN
KNIGHT

BY

DAVID LOWERY

WHEN HONOR WAS EVERYTHING.

WHEN COURAGE MADE KINGS.

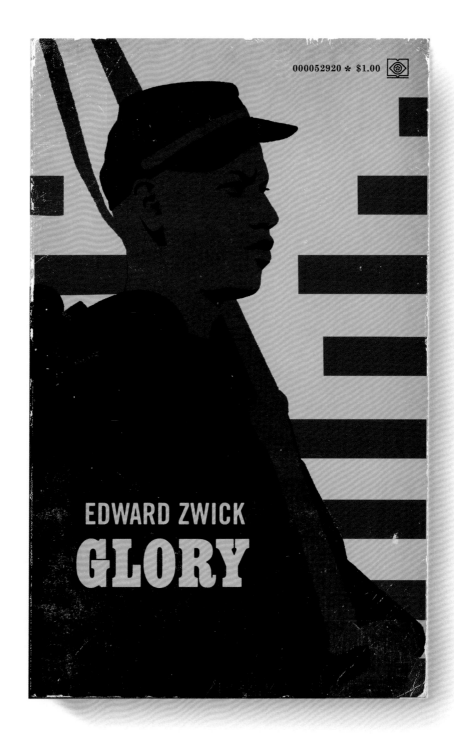

000052920 ✳ $1.00

EDWARD ZWICK

GLORY

196 *Glory* (1989) / Director: Edward Zwick / Writer: Kevin Jarre / Original Works: *Lay This Laurel* by Lincoln Kirstein, *One Gallant Rush* by Peter Burchard, and the personal letters of Robert Gould Shaw

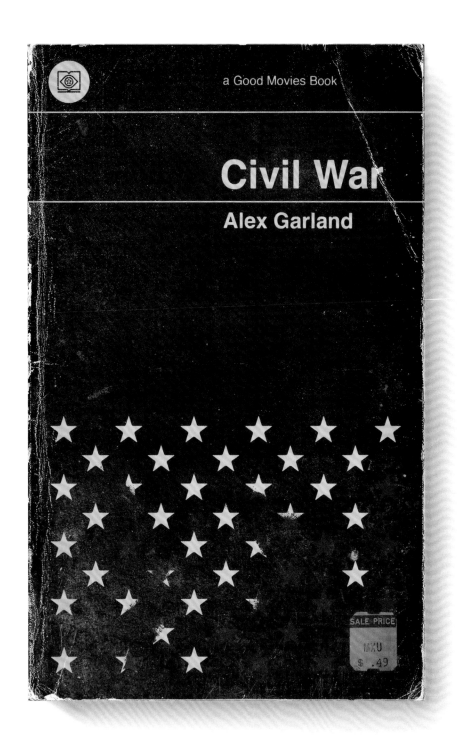

Civil War (2024) / Director: Alex Garland / Writer: Alex Garland

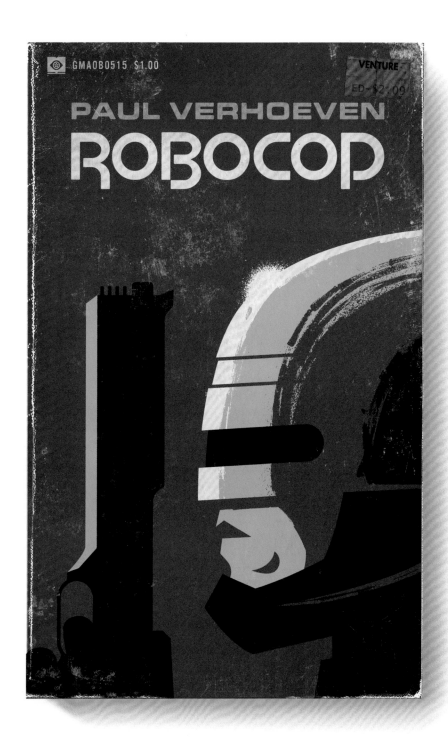

RoboCop (1987) / Director: Paul Verhoeven / Writers: Edward Neumeier, Michael Miner

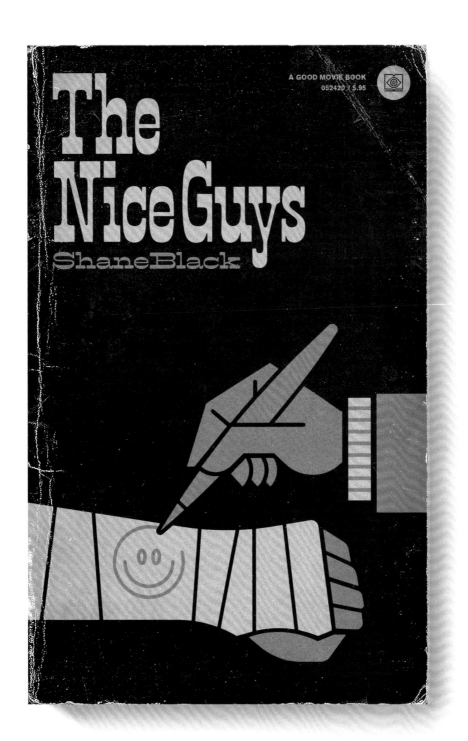

The Nice Guys (2016) / Director: Shane Black / Writers: Shane Black, Anthony Bagarozzi

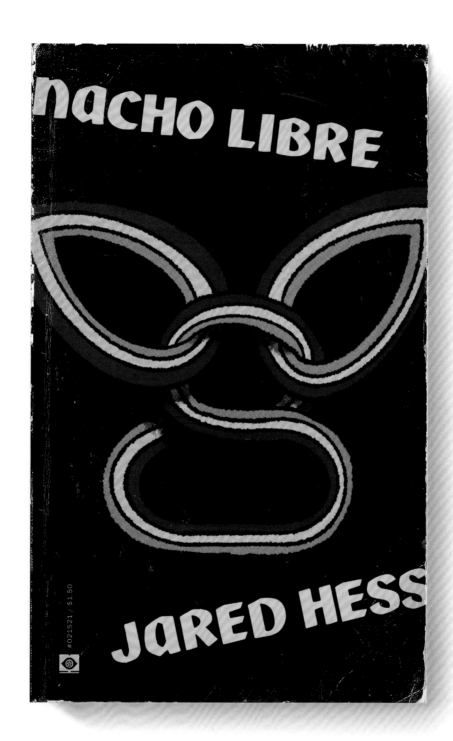

Nacho Libre (2006) / Director: Jared Hess / Writers: Jared Hess, Jerusha Hess, Mike White

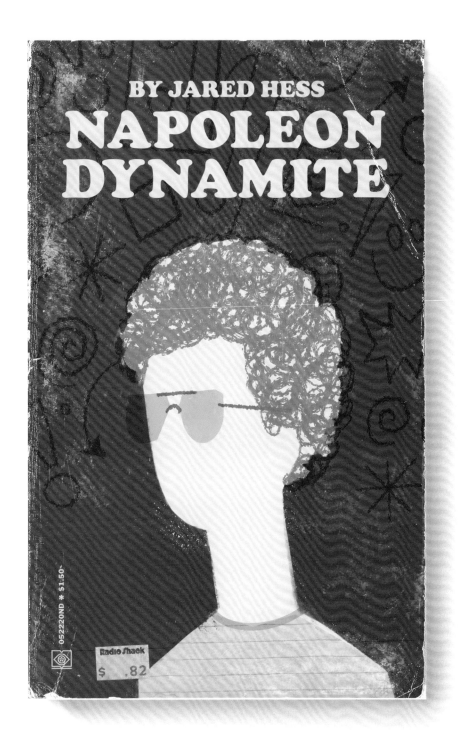

Napoleon Dynamite (2004) / Director: Jared Hess / Writers: Jared Hess, Jerusha Hess

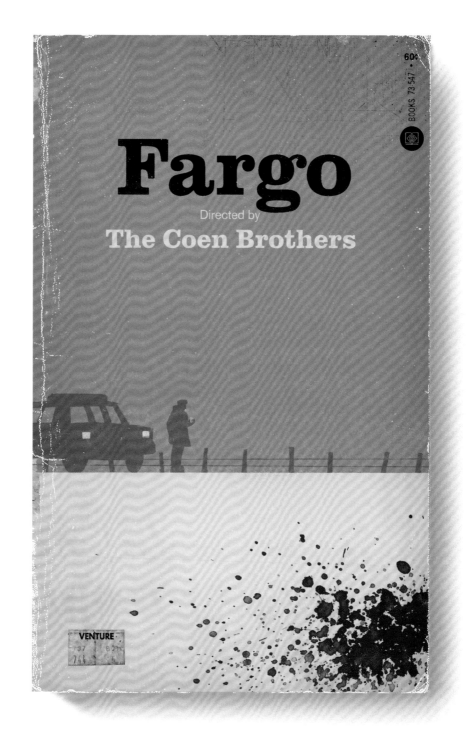

Fargo (1996) / Directors: Joel Coen, Ethan Coen / Writers: Ethan Coen, Joel Coen

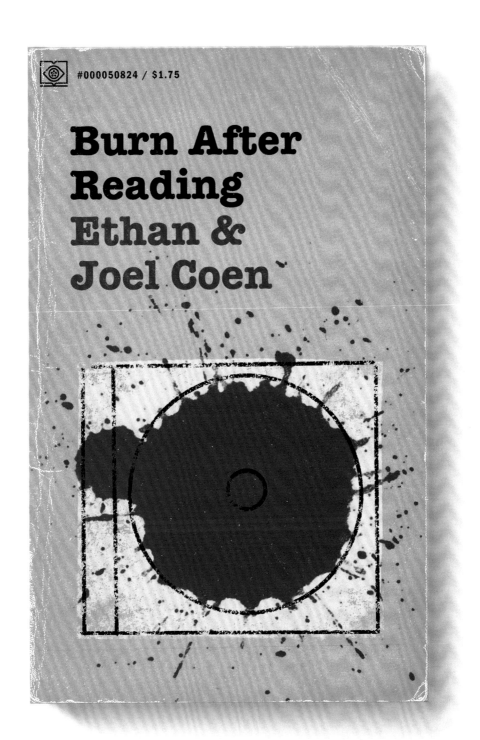

#000050824 / $1.75

Burn After Reading
Ethan & Joel Coen

Burn After Reading (2008) / Directors: Ethan Coen, Joel Coen / Writers: Joel Coen, Ethan Coen

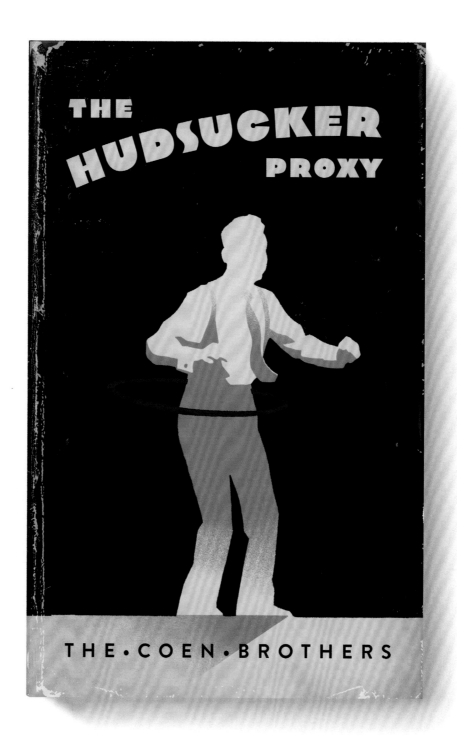

The Hudsucker Proxy (1994) / Directors: Joel Coen, Ethan Coen / Writers: Ethan Coen, Joel Coen, Sam Raimi

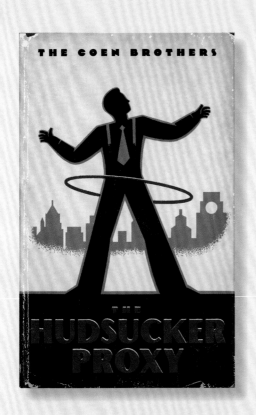

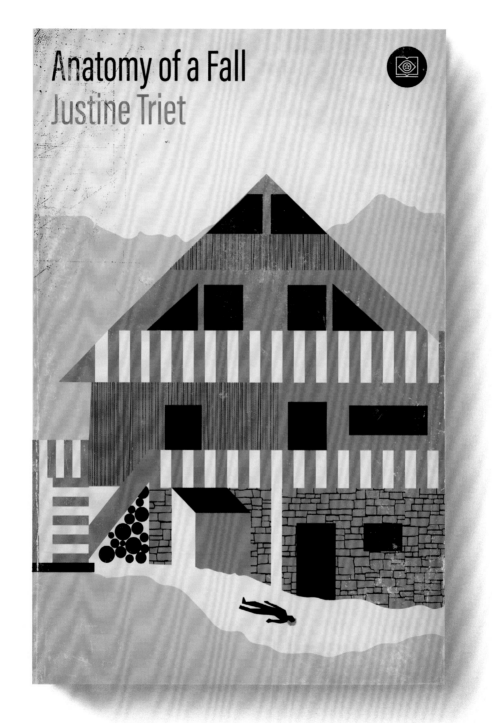

Anatomy of a Fall (2023) / Director: Justine Triet / Writers: Justine Triet, Arthur Harari

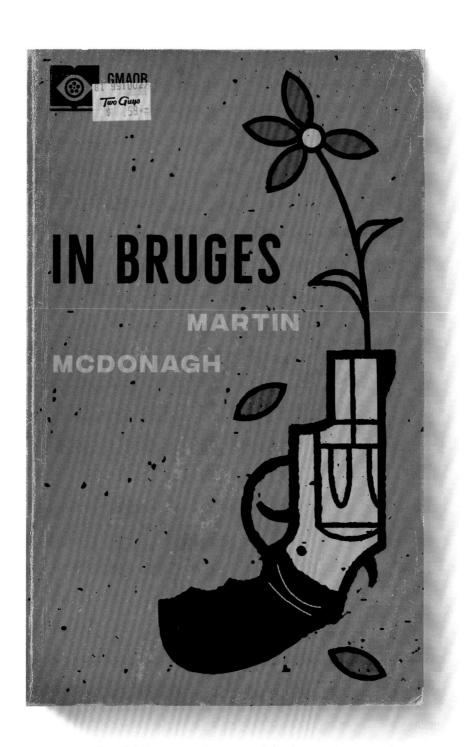

In Bruges (2008) / Director: Martin McDonagh / Writer: Martin McDonagh

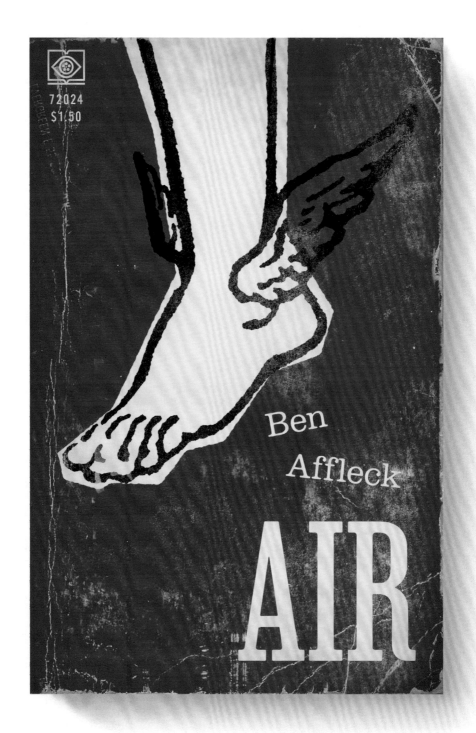

Ben
Affleck

AIR

Air (2023) / Director: Ben Affleck / Writer: Alex Convery

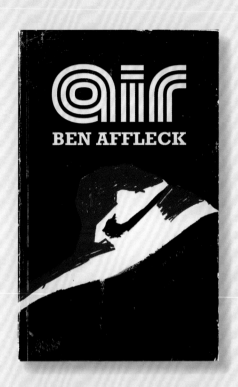

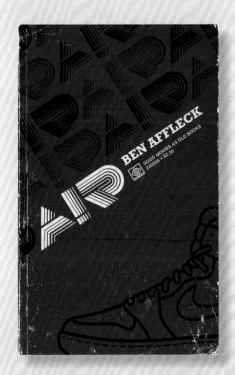

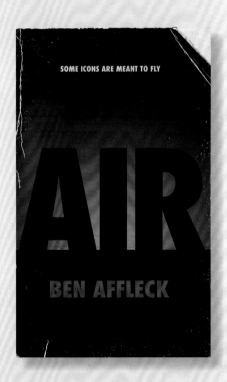

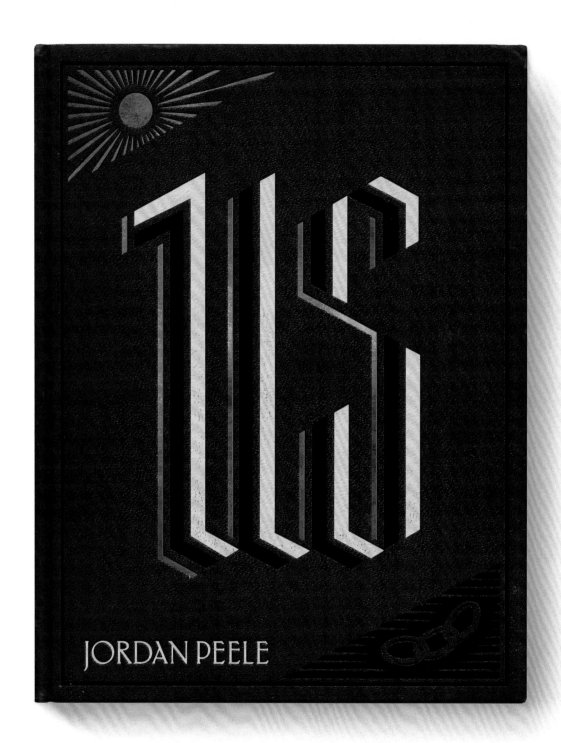

Us (2019) / Director: Jordan Peele / Writer: Jordan Peele

US

WE ARE OUR OWN

WORST ENEMY

DIRECTED BY

JORDAN PEELE

MMXIX

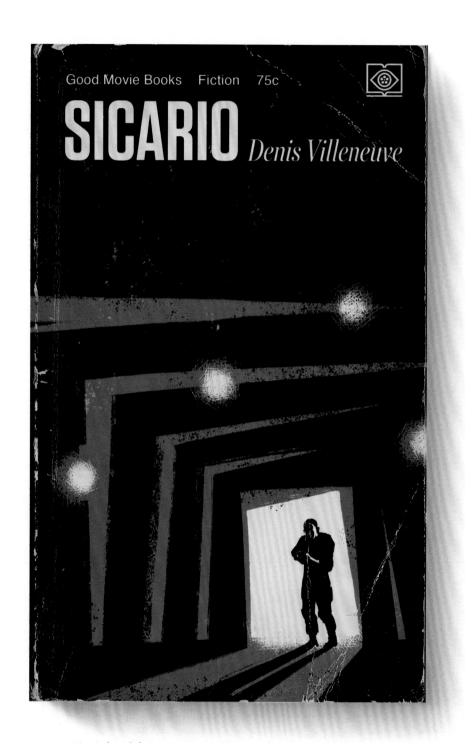

Sicario (2015) / Director: Denis Villeneuve / Writer: Taylor Sheridan

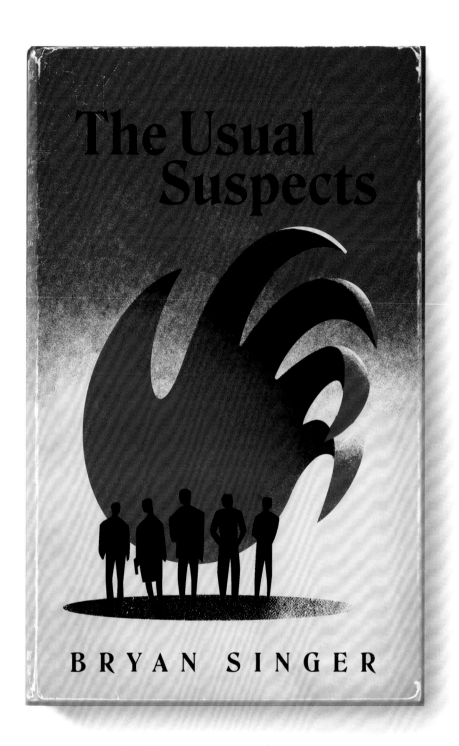

The Usual Suspects (1995) / Director: Bryan Singer / Writer: Christopher McQuarrie

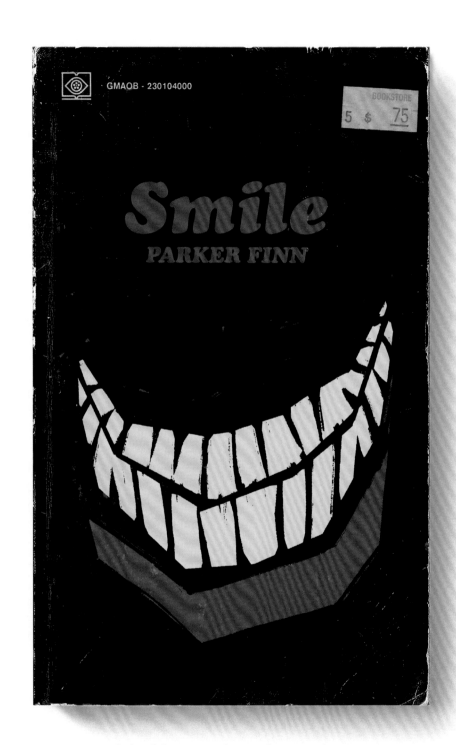

Smile (2022) / Director: Parker Finn / Writer: Parker Finn

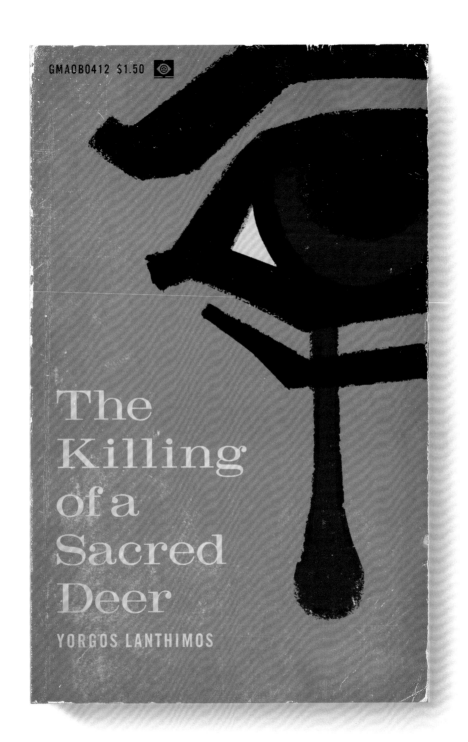

GMAOB0412 $1.50

The Killing of a Sacred Deer

YORGOS LANTHIMOS

The Killing of a Sacred Deer (2017) / Director: Yorgos Lanthimos
Writers: Yorgos Lanthimos, Efthimis Filippou

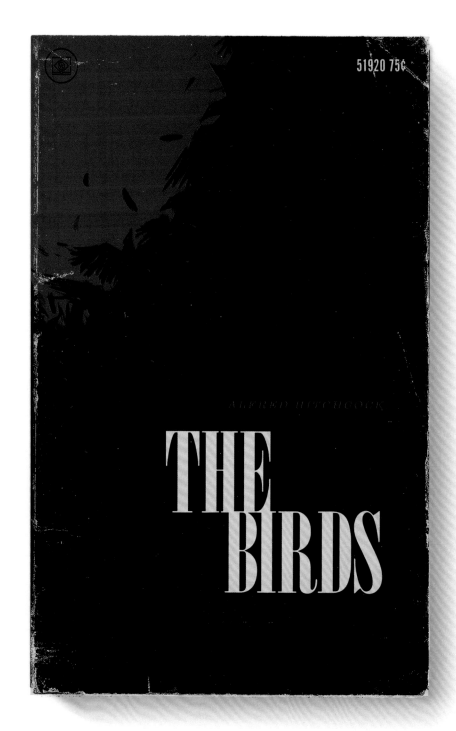

ALFRED HITCHCOCK

THE
BIRDS

51920 75¢

The Birds (1963) / Director: Alfred Hitchcock / Writer: Evan Hunter
Original Short Story: Daphne du Maurier

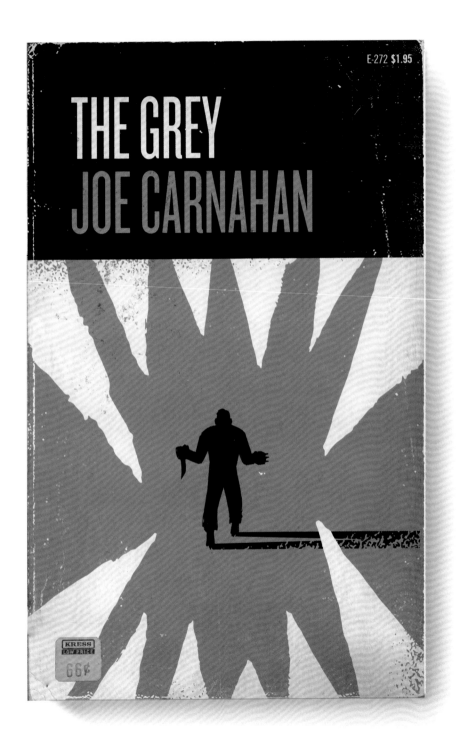

The Grey (2011) / Director: Joe Carnahan / Writers: Joe Carnahan, Ian Mackenzie Jeffers
Original Novel: Ian Mackenzie Jeffers

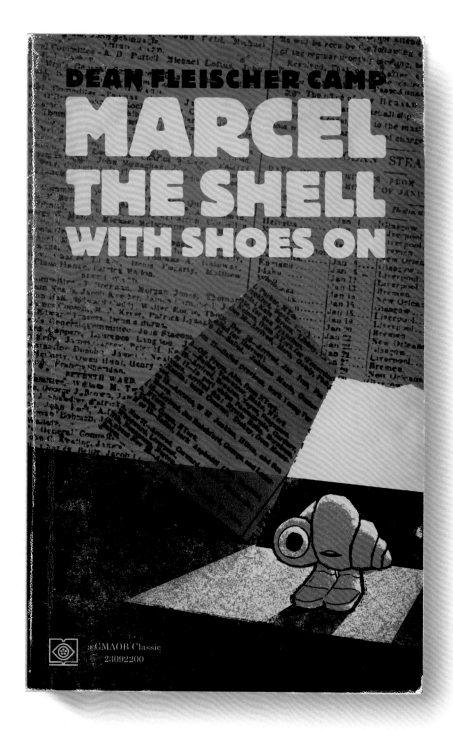

Marcel the Shell with Shoes On (2021) / Director: Dean Fleischer Camp
Writers: Dean Fleischer Camp, Jenny Slate, Nick Paley

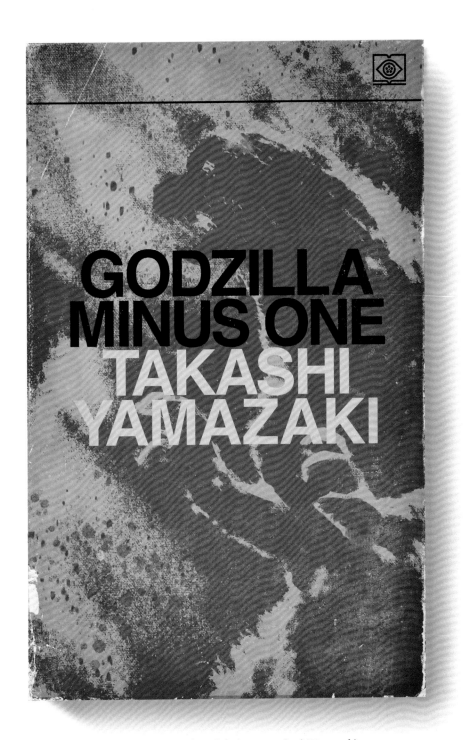

Godzilla Minus One (2023) / Director: Takashi Yamazaki
Writers: Takashi Yamazaki, Ishirô Honda, Takeo Murata

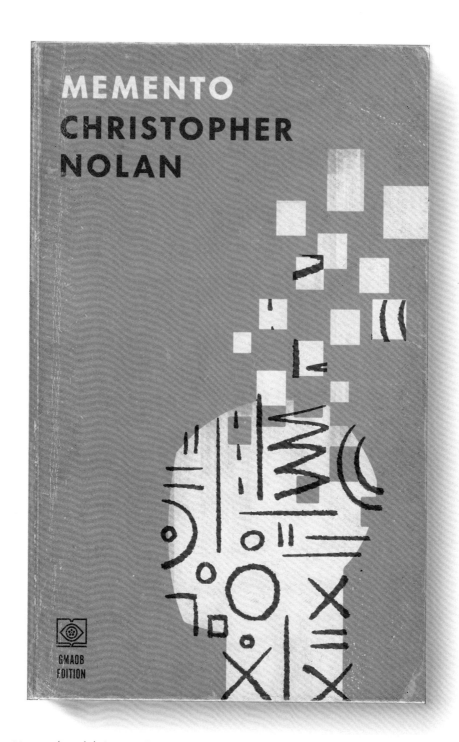

220　　*Memento* (2000) / Director: Christopher Nolan / Writers: Christopher Nolan, Jonathan Nolan

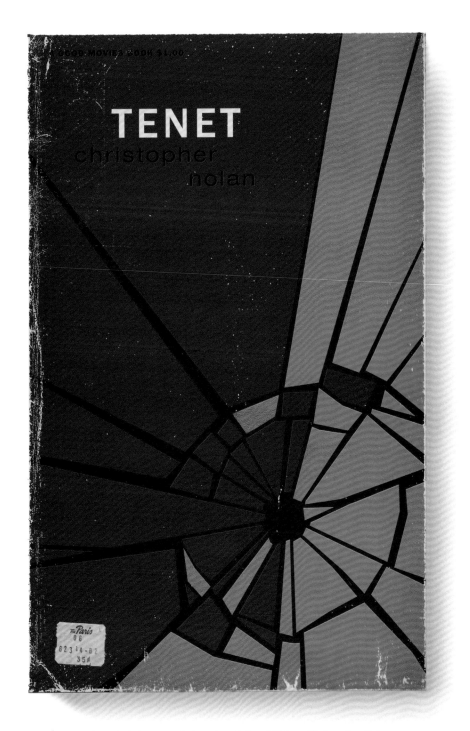

TENET
christopher
nolan

Tenet (2020) / Director: Christopher Nolan / Writer: Christopher Nolan

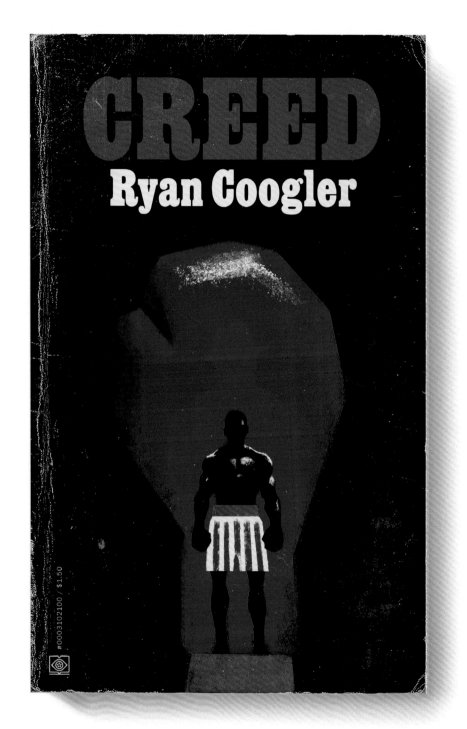

Creed (2015) / Director: Ryan Coogler / Writers: Ryan Coogler, Aaron Covington, Sylvester Stallone

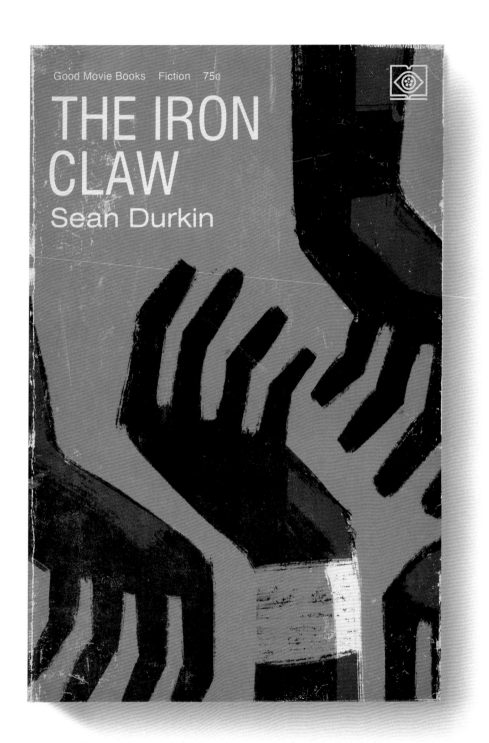

Good Movie Books　　Fiction　　75¢

THE IRON CLAW
Sean Durkin

The Iron Claw (2023) / Director: Sean Durkin / Writer: Sean Durkin

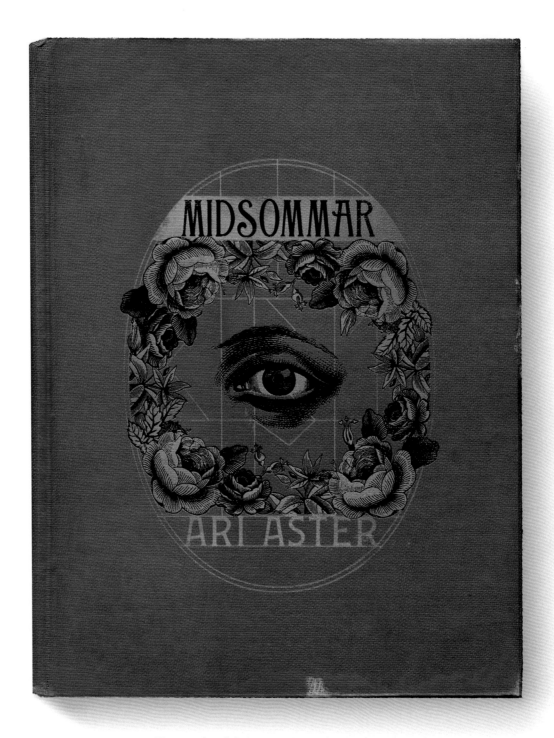

Midsommar (2019) / Director: Ari Aster / Writer: Ari Aster

MIDSOMMAR

MMXIX

ARI ASTER

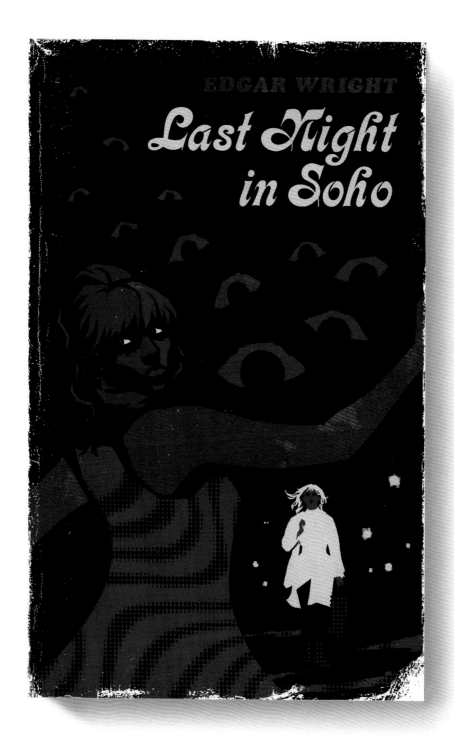

Last Night in Soho (2021) / Director: Edgar Wright / Writers: Edgar Wright, Krysty Wilson-Cairns

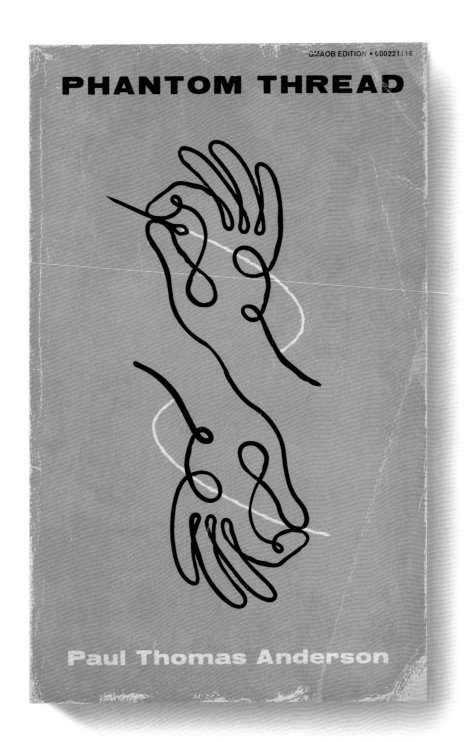

Phantom Thread (2017) / Director: Paul Thomas Anderson / Writer: Paul Thomas Anderson

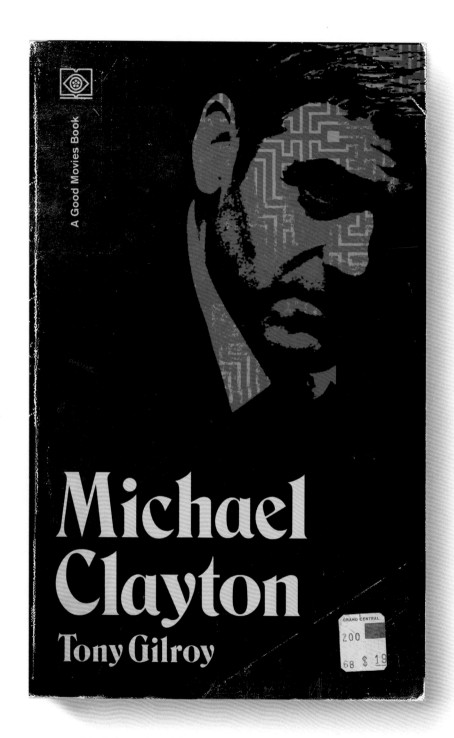

A Good Movies Book

Michael Clayton

Tony Gilroy

GRAND CENTRAL
200
68 $ 19

Michael Clayton (2007) / Director: Tony Gilroy / Writer: Tony Gilroy

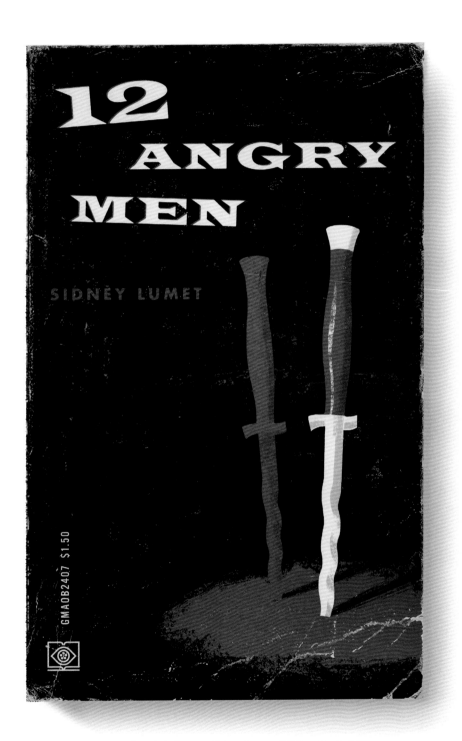

12 Angry Men (1957) / Director: Sidney Lumet / Writer: Reginald Rose

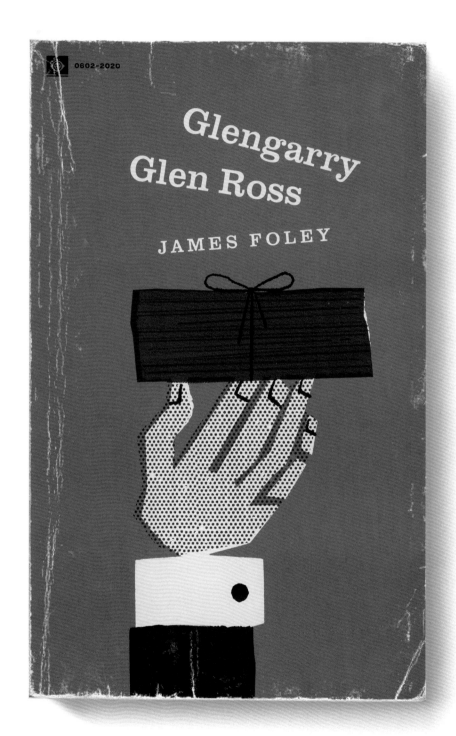

Glengarry Glen Ross (1992) / Director: James Foley / Writer: David Mamet / Original Play: David Mamet

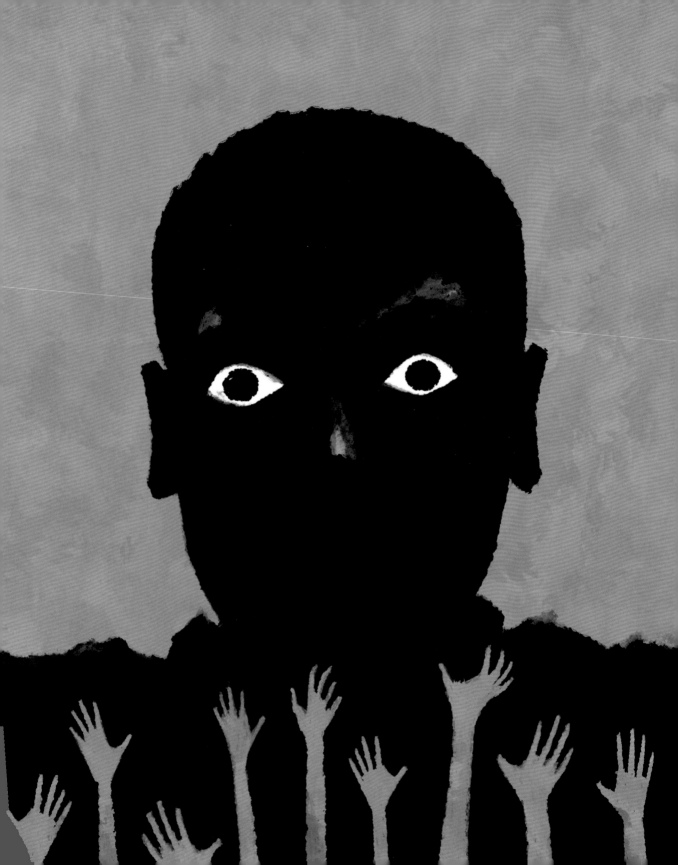

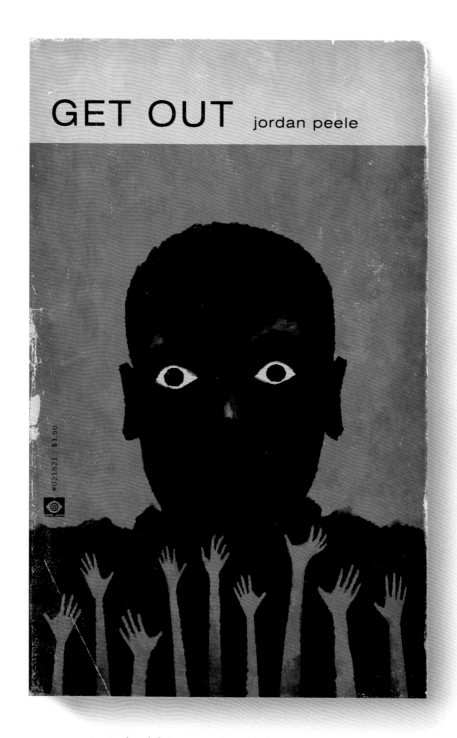

GET OUT jordan peele

#021821 $1.50

Get Out (2017) / Director: Jordan Peele / Writer: Jordan Peele

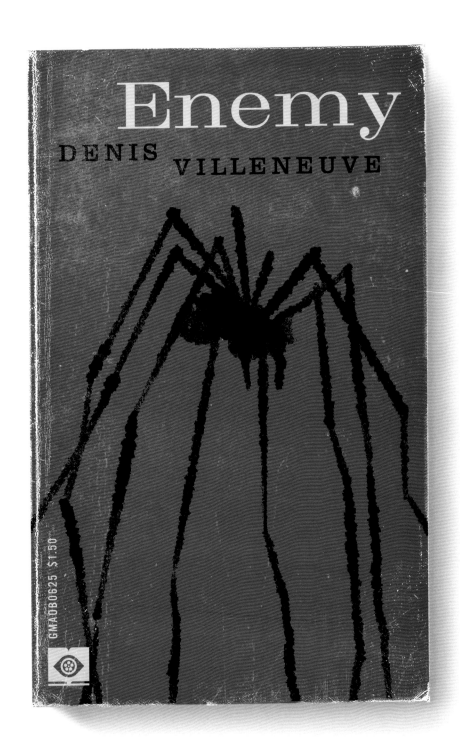

Enemy (2013) / Director: Denis Villeneuve / Writers: José Saramago, Javier Gullón

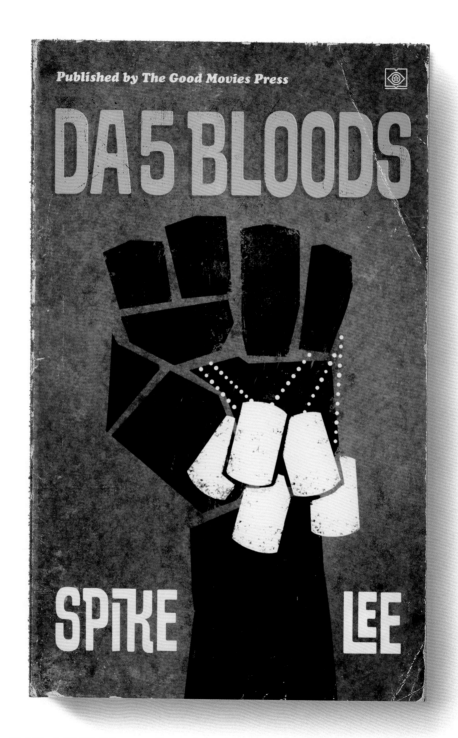

Da5 Bloods (2020) / Director: Spike Lee / Writers: Danny Bilson, Paul De Meo, Kevin Willmott, Spike Lee, Matthew Billingsly (uncredited)

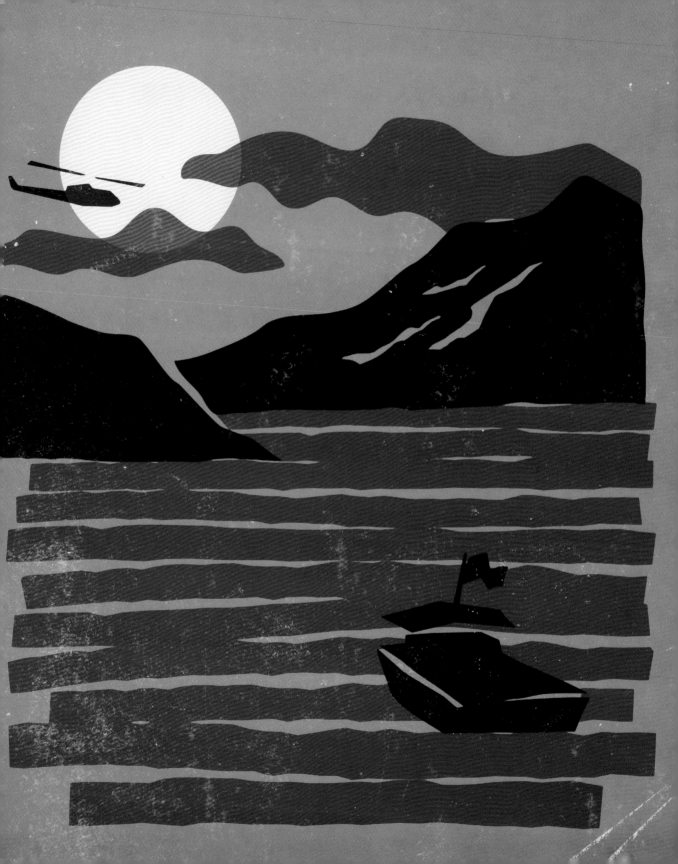

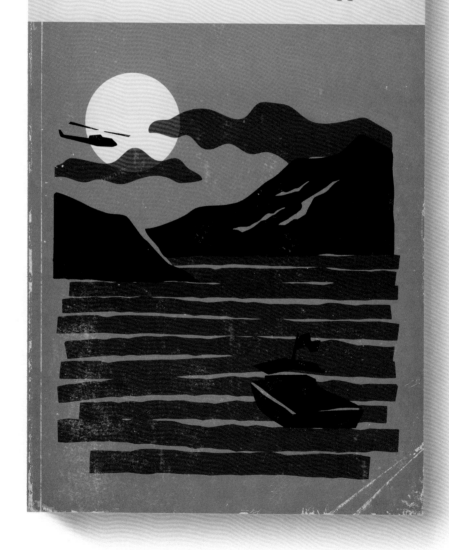

Apocalypse Now

Francis Ford Coppola

236 *Apocalypse Now* (1979) / Director: Francis Ford Coppola / Writers: John Milius,
Francis Ford Coppola, Michael Herr, Joseph Conrad (uncredited)

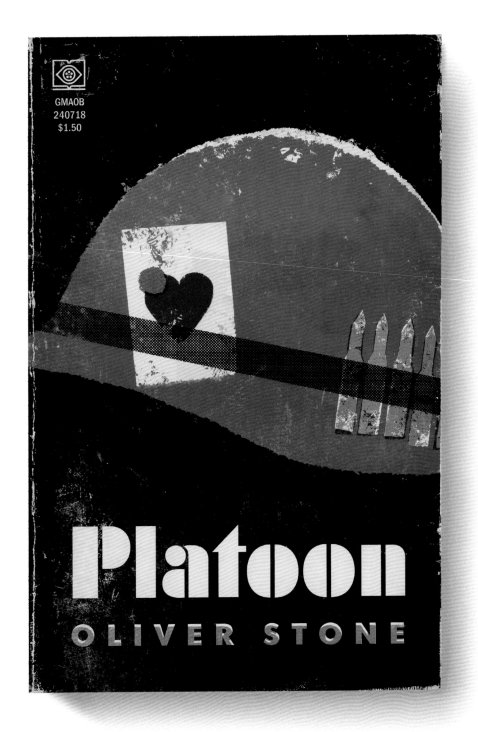

Platoon

OLIVER STONE

Platoon (1986) / Director: Oliver Stone / Writer: Oliver Stone

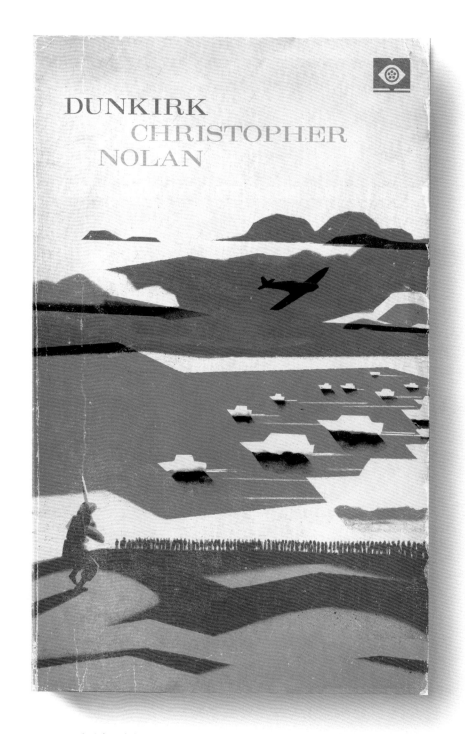

Dunkirk (2017) / Director: Christopher Nolan / Writer: Christopher Nolan

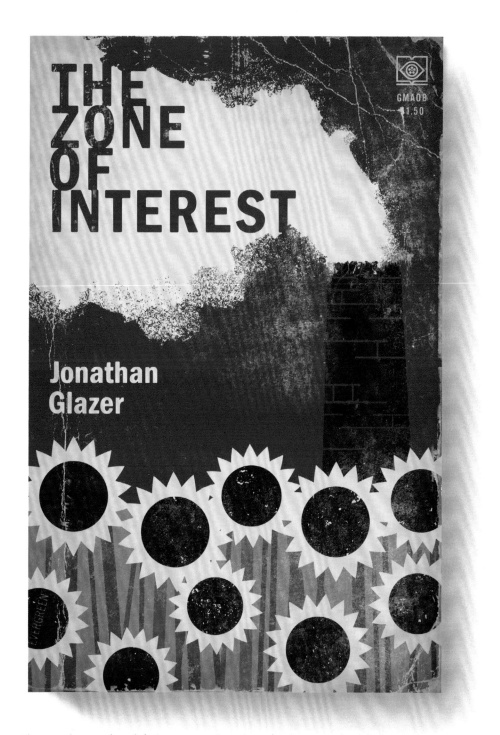

The Zone of Interest (2023) / Director: Jonathan Glazer / Writers: Jonathan Glazer, Martin Amis

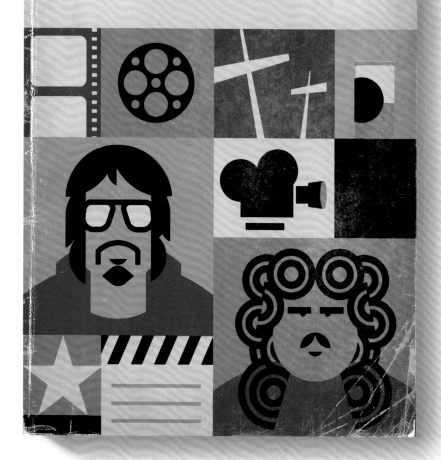

CHRIS SMITH

AMERICAN MOVIE

GMA0B0412 $1.50

American Movie (1999) / Director: Chris Smith

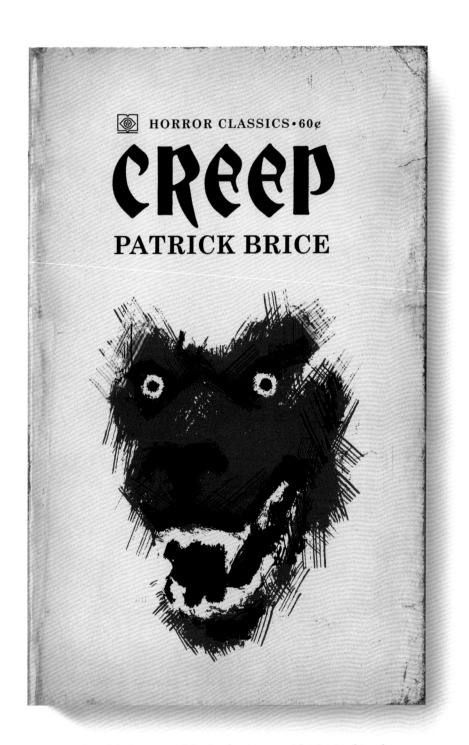

Creep (2014) / Director: Patrick Brice / Writers: Patrick Brice, Mark Duplass

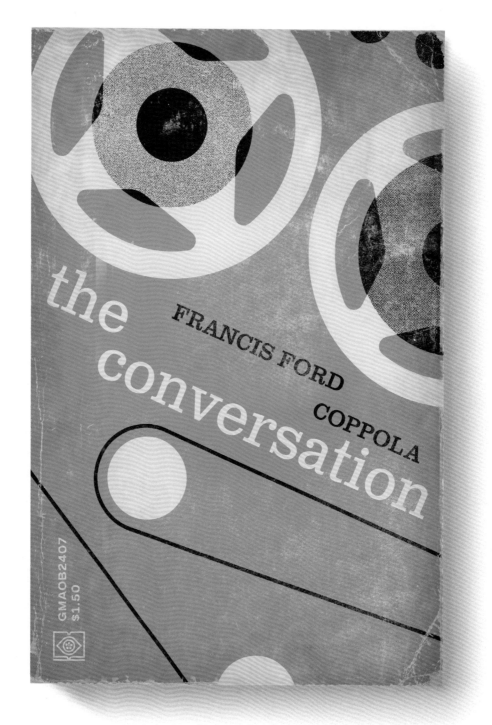

FRANCIS FORD

COPPOLA

the conversation

GMAOB2407
$1.50

The Conversation (1974) / Director: Francis Ford Coppola / Writer: Francis Ford Coppola

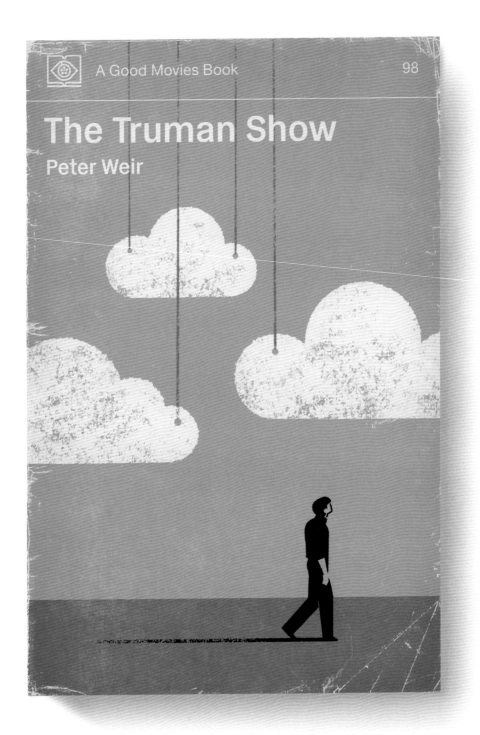

The Truman Show (1998) / Director: Peter Weir / Writer: Andrew Niccol

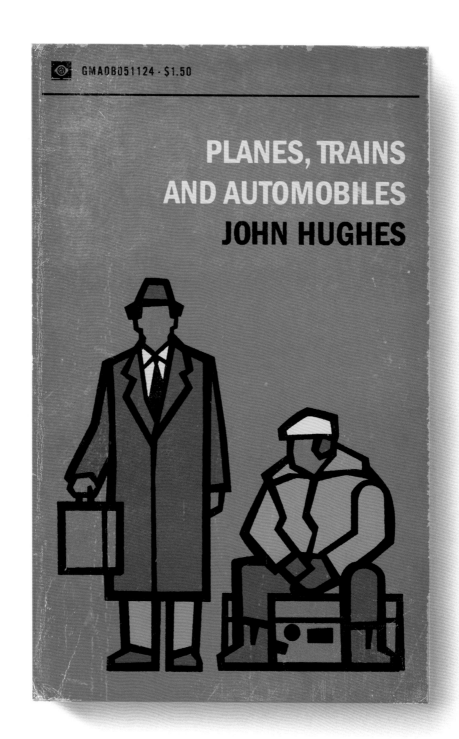

PLANES, TRAINS
AND AUTOMOBILES
JOHN HUGHES

GMA0B051124 · $1.50

Planes, Trains and Automobiles (1987) / Director: John Hughes / Writer: John Hughes

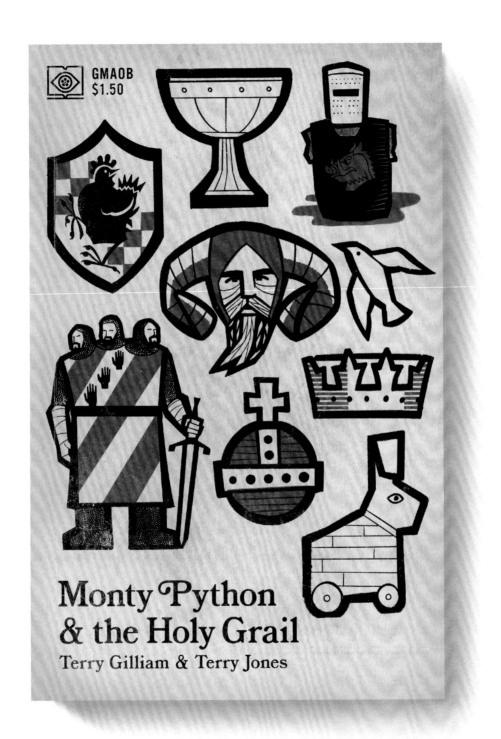

GMAOB
$1.50

Monty Python
& the Holy Grail
Terry Gilliam & Terry Jones

Monty Python and the Holy Grail (1975) / Directors: Terry Gilliam, Terry Jones / Writers: Graham Chapman, John Cleese, Eric Idle, Terry Gilliam, Terry Jones, Michael Palin, Thomas Malory (uncredited)

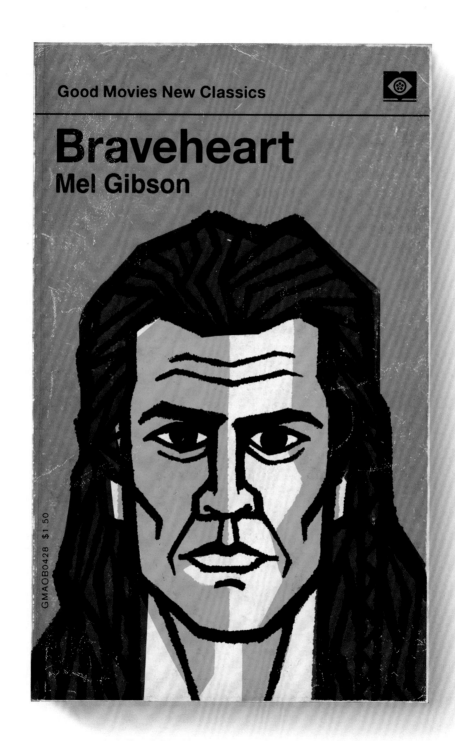

Good Movies New Classics

Braveheart
Mel Gibson

GMAOB0428 $1.50

Braveheart (1995) / Director: Mel Gibson / Writer: Randall Wallace

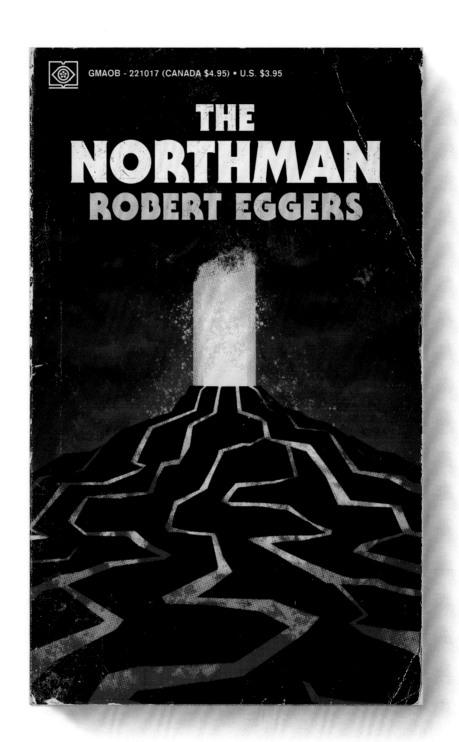

The Northman (2022) / Director: Robert Eggers / Writers: Sjón, Robert Eggers

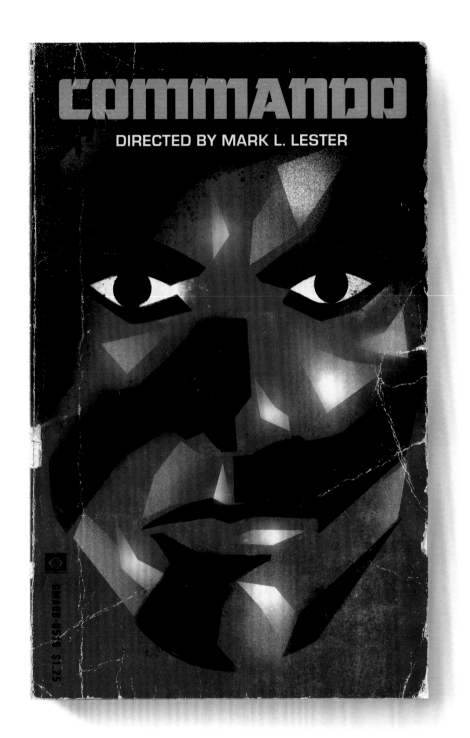

Commando (1985) / Director: Mark L. Lester / Writers: Jeph Loeb, Matthew Weisman, Steven E. de Souza 251

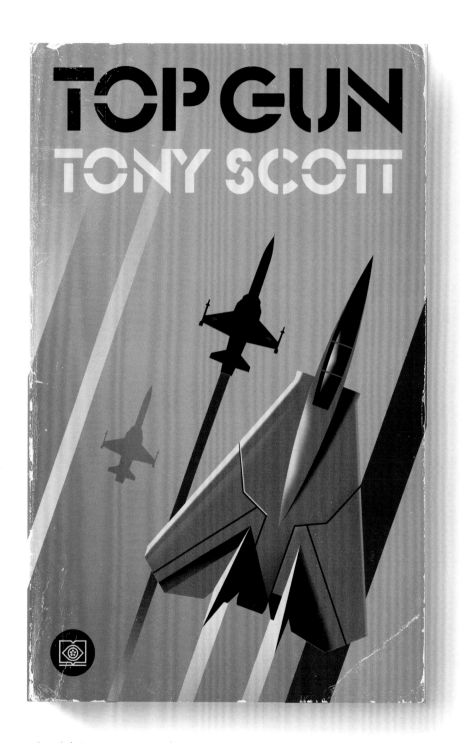

Top Gun (1986) / Director: Tony Scott / Writers: Jim Cash, Jack Epps Jr. / Original Article: Ehud Yonay

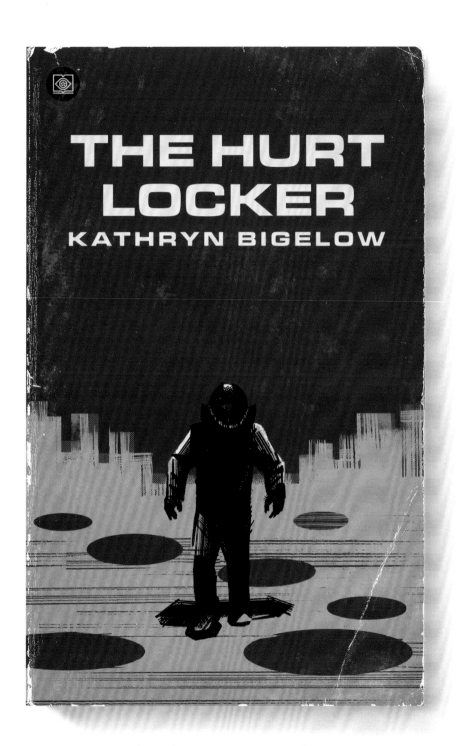

The Hurt Locker (2008) / Director: Kathryn Bigelow / Writer: Mark Boal

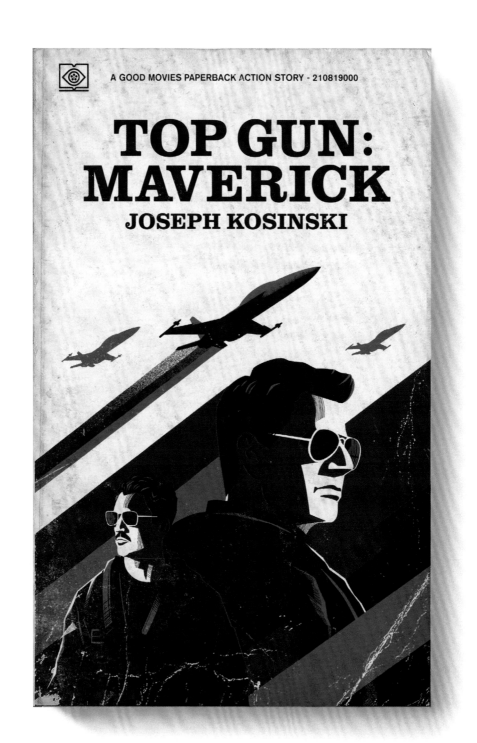

Top Gun: Maverick (2022) / Director: Joseph Kosinski / Writers: Jim Cash, Jack Epps Jr., Peter Craig

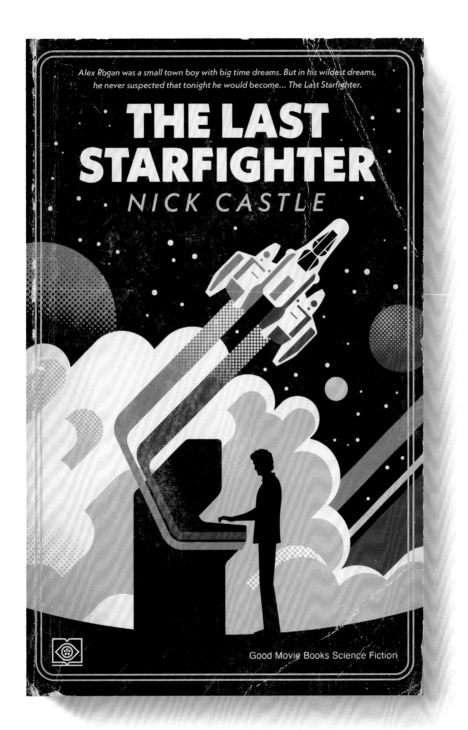

The Last Starfighter (1984) / Director: Nick Castle / Writer: Jonathan R. Betuel

Library of Congress Cataloging-in-Publication Data available.

ISBN 978-1-7972-3219-5

Manufactured in China.

Design by Wynne Au-Yeung.

10 9 8 7 6 5 4 3 2 1

Chronicle books and gifts are available at special quantity discounts to corporations, professional associations, literacy programs, and other organizations. For details and discount information, please contact our premiums department at corporatesales@chroniclebooks.com or at 1-800-759-0190.

Chronicle Books LLC
680 Second Street
San Francisco, California 94107
www.chroniclebooks.com

Monty Python & the Holy Grail
Terry Gilliam & Terry Jones

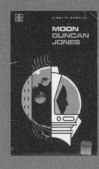
MOON
DUNCAN JONES

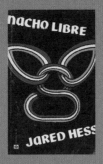
nacho libre
JARED HESS

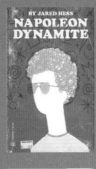
BY JARED HESS
NAPOLEON DYNAMITE

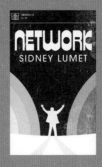
NETWORK
SIDNEY LUMET

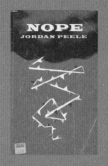
NOPE
JORDAN PEELE

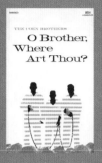
THE COEN BROTHERS
O Brother, Where Art Thou?

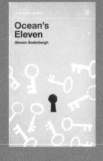
Ocean's Eleven
Steven Soderbergh

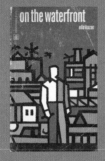
on the waterfront
elia kazan

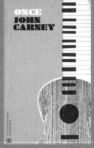
ONCE
JOHN CARNEY

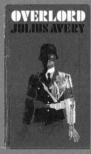
OVERLORD
JULIUS AVERY

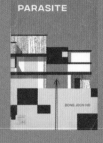
PARASITE
BONG JOON HO

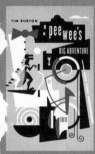
TIM BURTON
pee wee's BIG ADVENTURE

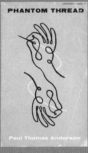
PHANTOM THREAD
Paul Thomas Anderson

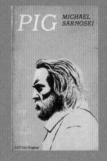
PIG
MICHAEL SARNOSKI

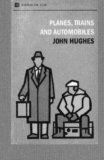
PLANES, TRAINS AND AUTOMOBILES
JOHN HUGHES

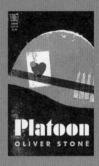
Platoon
OLIVER STONE

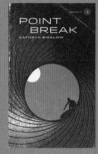
POINT BREAK
KATHRYN BIGELOW

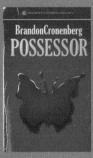
Brandon Cronenberg
POSSESSOR

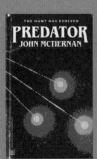
THE HUNT HAS EVOLVED
PREDATOR
JOHN MCTIERNAN

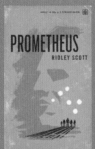
PROMETHEUS
RIDLEY SCOTT

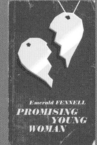
Emerald FENNELL
PROMISING YOUNG WOMAN

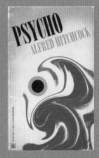
PSYCHO
ALFRED HITCHCOCK

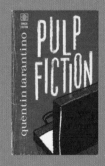
quentin tarantino
PULP FICTION

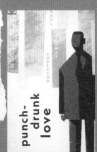
punch-drunk love

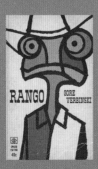
RANGO
GORE VERBINSKI

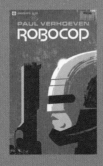
PAUL VERHOEVEN
ROBOCOP

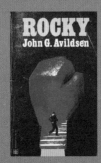
ROCKY
John G. Avildsen

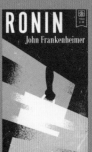
RONIN
John Frankenheimer

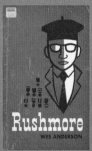
Rushmore
WES ANDERSON

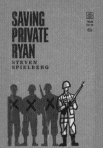
SAVING PRIVATE RYAN
STEVEN SPIELBERG

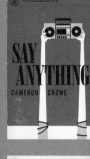
SAY ANYTHING
CAMERON CROWE

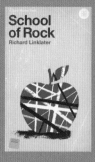
School of Rock
Richard Linklater

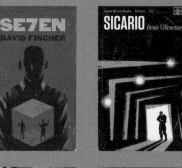
SE7EN
DAVID FINCHER

SICARIO Denis Villeneuve

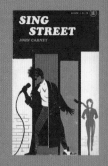
SING STREET
JOHN CARNEY

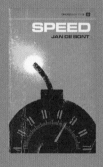
SPEED
JAN DE BONT

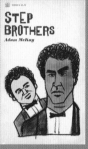
STEP BROTHERS
Adam McKay

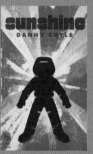
sunshine
DANNY BOYLE

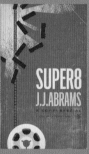
SUPER8
J.J.ABRAMS

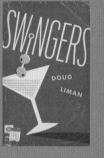
SWINGERS
DOUG LIMAN

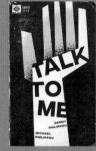
TALK TO ME
DANNY PHILIPPOU
MICHAEL PHILIPPOU

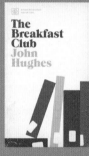
The Breakfast Club
John Hughes

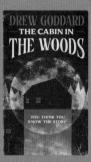
DREW GODDARD
THE CABIN IN THE WOODS
YOU THINK YOU KNOW THE STORY.

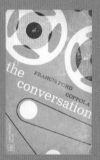
the conversation
FRANCIS FORD COPPOLA

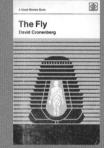
The Fly
David Cronenberg

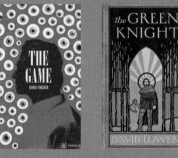
THE GAME
DAVID FINCHER

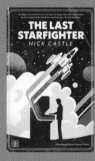
the **GREEN KNIGHT**
DAVID LOWERY

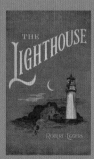
THE LAST STARFIGHTER
NICK CASTLE

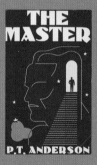
THE LIGHTHOUSE
ROBERT EGGERS

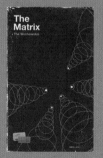
THE MASTER
P.T. ANDERSON

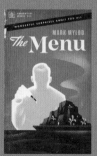
The Matrix
The Wachowskis

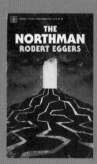
MARK MYLOD
The Menu
WONDERFUL SURPRISES AWAIT YOU ALL

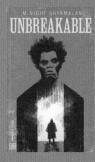
THE NORTHMAN
ROBERT EGGERS

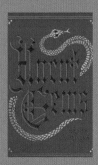
M. NIGHT SHYAMALAN
UNBREAKABLE

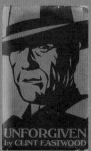

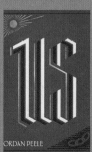
UNFORGIVEN
by CLINT EASTWOOD

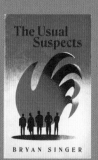
US
JORDAN PEELE

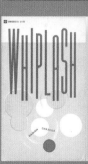
The Usual Suspects
BRYAN SINGER

WHIPLASH